Rowena

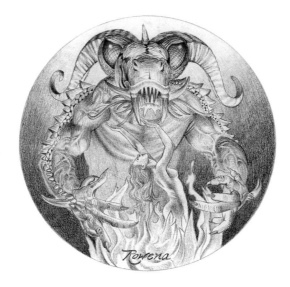

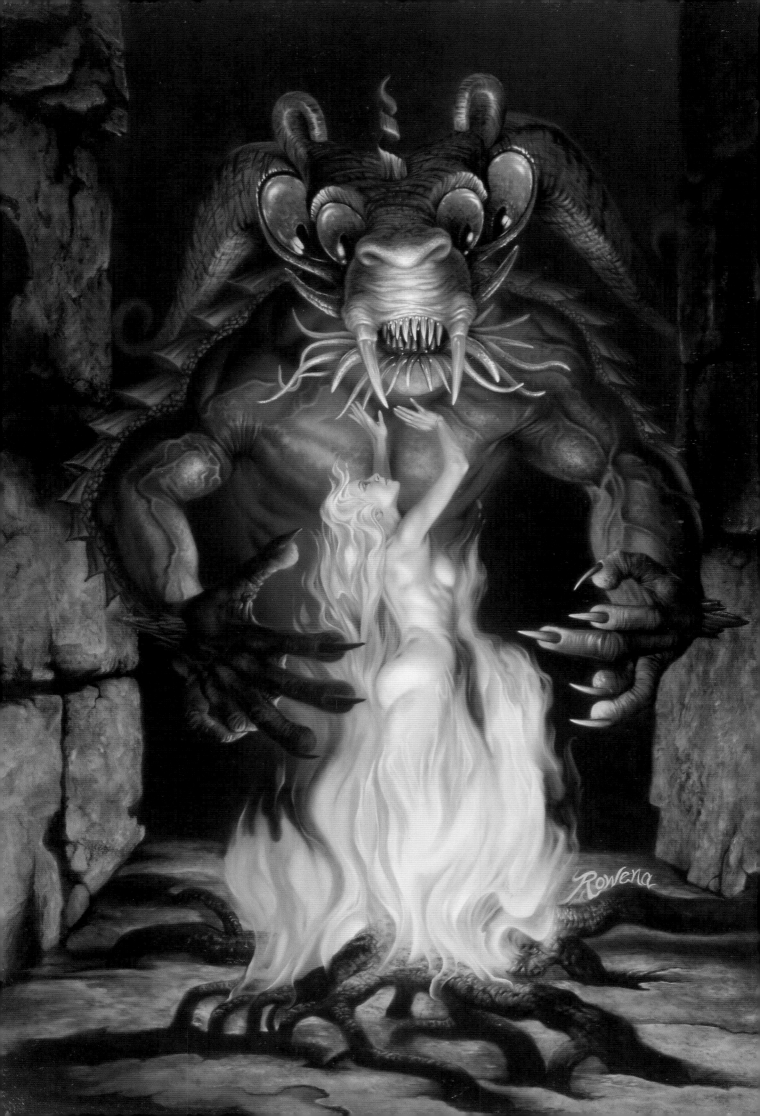

THE ART OF
ROWENA

ROWENA MORRILL
TEXT BY DORIS VALLEJO

FOREWORD BY GREG AND TIM HILDEBRANDT

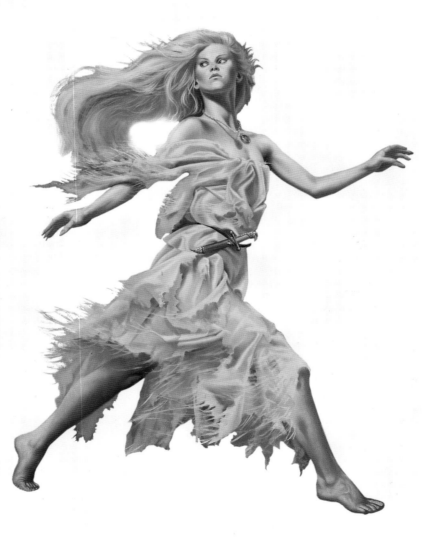

Paper Tiger

With loving thanks to Fabio Chiussi
for his support and inspiration.

First published in Great Britain in 2000 by Paper Tiger
an imprint of Collins & Brown Limited
London House
Great Eastern Wharf
Parkgate Road
London SW11 4NQ

www.papertiger.co.uk

Distributed in the United States and Canada
by Sterling Publishing Co.,
387 Park Avenue South, New York, NY 10016, USA

135798642

British Library Cataloguing-in-Publication Data:
A catalogue record for this book is available from the British Library.

ISBN 1 85585 778 2

Designed by Malcolm Couch
Edited by Jane Ellis

Reproduction by Bluetag, London
Printed and Bound by Sing Cheong Printing Co., Ltd., Hong Kong

Facing title page:
NIGHT DEMON AND FIRE GIRL
TRADING CARD BOX COVER

I have spent many evenings sitting in front of a campfire after dark, watching the flames, daydreaming, and discovering half-imagined shapes moving before me. The idea of a creature materializing out of the darkness, firelight brushing his night-veiled features, evoked such a beguiling sense of mystery. Here, once again, I am playing with contrasts: a shadowy creature conjuring up a fiery one.

Doris posed for the fire girl. I took 24 shots of her with her arms up in the air, with just slight variations from pose to pose. Anyone looking at those photos would have wondered what in the world we were trying to achieve. We took the film to a one-hour processing shop. The salesman must have recognized Doris from the pictures when we returned to collect them, as he had a distinctly strange grin on his face.

CONTENTS

FOREWORD

THE YEAR WAS 1978. We had just completed our third J.R.R. Tolkien Calendar for Ballantine Books. Ian Summers, Ballantine's art director, had finished compiling and editing *Tomorrow and Beyond*, an anthology of prominent contemporary science fiction and fantasy illustrators. That was the first time we became aware of Rowena's work.

As all artists do, we constantly compare the work of other artists to our own, studying it for methods and techniques we might learn from. Rowena's paintings made an instant impression on us.

When you view art you have two separate reactions. The first is always a critical judgement of the piece; the second is an emotional reaction to it. But when a painting hits you both emotionally and critically, it is a unique experience. Rowena's paintings are luscious and full of life. In each one there is much to learn from Rowena's drawing, rendering and imagination. Imagination in art is primary. According to Einstein, imagination is far more important than knowledge.

We don't make a habit of going into bookstores and poring over the racks. We'll flip through pages until we come to a piece that seems outstanding, both in concept and in execution, and say, 'Hey, look at this!' What tends to overwhelm us in these cases is the intimate familiarity we have with our own struggles. And 'outstanding' is exactly how we'd describe Rowena's work. For starters, she is a superb artist and her art stands out in a field of so many excellent artists.

What makes Rowena's imagery different? A whole lot. You could begin with the difference between male and female energies. Her work has a feminine quality. It isn't characterized by dominant men overpowering submissive women. Her women are powerful. Even when they are not dominant, there is strength in their poses, their moods and their sensuousness.

That's especially true of the latest works that she did for herself. You can really see they were coming from inside her, from her heart, and not just produced because there was money at the other end. There are single strong images that register quickly. Her women have a classy look. Her monsters seem as though they could come to life. A great example would be the one jumping out of the water in *Permette Signorina* (see pp. 20–21). Her very proficient rendering aside, it's her surreal ideas that hit you head on: What part is reality? How often do we say, 'Is this really happening?' Rowena's paintings are open to all kinds of interpretations. Each one has a story, but what is it? Her paintings make you think.

Stone Demon (see p. 23) is one of our favourites. The subtlety of the rendering blows us away: the cools, the bounced, warm light, the way the glancing light hits underneath the fingers. Any part of it is a complete painting. Your eye can rest on tiny areas for long periods of time. The piece draws you in – something is there, something is happening. You get nearer and nearer and you can believe that the statue has really come to life.

Andrew Wyeth talks about seeing an image, moving increasingly closer to it, and getting to see more and more. That's what we get from Rowena's paintings. We can keep moving closer. We can get lost in them. There are pictures within pictures within pictures. We could literally blow those little pictures up, put them under a magnifying glass, and they would still work.

Dragon's Serenade (see pp. 24–5) is a perfect example. As beautiful as the creature and the woman are, we can't keep our eyes off the water. It looks real and alive. It has obviously been planned out, drawn, and then painted. The feminine consciousness is particularly evident here, and not just in the subject matter. It is obvious in Rowena's choice of composition, style and technique. It is in the care, the love and the tremendous amount of patience, which are so clearly visible.

She laughs when we tell her this. 'That's probably because I don't have the natural talent to knock it out,' she says. 'I have to put longer hours into it.' To that we have only one response. 'What is natural talent? Is it the opposite of unnatural talent?' Her paintings don't appear laboured-over.

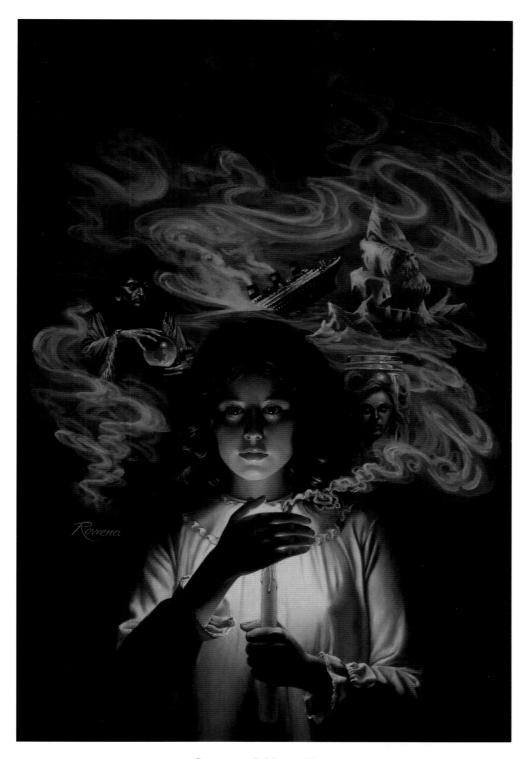

GHOSTS I HAVE BEEN
RICHARD PECK

*T*his little girl is psychic and is having a vision of the *Titanic* sinking. I think the menacing background adds mystery to the scene and makes her look all the more vulnerable.

They look to be carefully, patiently, lovingly created. That has to be impressive, when what goes through our own heads at every phase of a painting from the concept to the thumbnail sketch to the actual piece is: Please God, let me live through this. Just let me stay alive long enough to finish it. Like the Ringo Starr song tells you: *It*

Don't Come Easy. Knowing Rowena makes a difference to us; knowing how she works, knowing her struggle. It lets us feel that we artists are all in this together. That makes for a wonderful connection.

Greg and Tim Hildebrandt,
New Jersey, December 1999

INTRODUCTION

ART IS BORN out of the lure of the elusive, that half-glimpsed imagery of inspiration. To *see* as an artist is to unearth a reality far different from that of the non-artist, whose view is essentially limited to the visible. An artist focuses beyond the visible, and each creation is drawn from the stuff of his or her private world. Just so with Rowena, for whom the creation of something beautiful is, as she says, 'The most potent thing you can do to combat the immutable losses in life.'

This does not imply that the painting of a beautiful flower is simply that and nothing more. Rather, it is the artist's unique interpretation of a flower and can comprise much beyond the obvious: feelings, thoughts, memories and dreams. There is more humour, for instance, in Rowena's monsters than in the lengthy repartee of many a stand-up comedian. As far as she is concerned, monsters and dragons are fun creatures; hers are usually grinning. This outlook might well have developed when she was in Japan as a child. There, such creatures were often seen as benevolent gods and symbols of luck. The temples were filled with magnificent statues of these deities, adorned with fabulously coloured jewels.

A recurrent theme in Rowena's work is the dichotomy of human nature. Her paintings build on contrasts of light and dark, perception and blindness, tumult and quiescence. The very process of living, she finds, continually takes us from the darkness into the sunlight and back again. It is a lifelong cycle of death and rebirth.

In her music these motifs are equally evident, as might be noted in *The Devil's Footsteps*, her most recently completed piece. It tells a story of curious beauty even in that which terrifies, and the final part, melodic and peaceful, bespeaks resolution: a coming to terms with terror and the ensuing serenity of acceptance.

Rowena views both her music and her painting (particularly the non-commissioned works that she does for her own pleasure) as a form of story-telling. It is a process of discovery and invention, of stretching toward the ever-fugitive pictures that flash up from the subconscious.

Music was Rowena's first love, even before she began to paint. It is therefore no surprise that composing provides a revitalizing break between commissioned paintings, as well as sparking fresh ideas for her next paintings. To become utterly immersed in the stages of creation is, for her, to enter a magical world, a place of excitement and energy, of discovery and growth, of newness, and infinite possibilities.

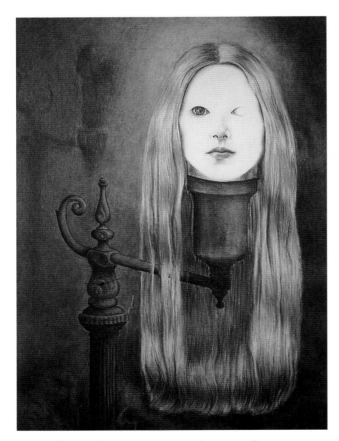

SELF-PORTRAIT AS A LIGHT BULB
Early drawing

Right:
THE DEVIL'S FOOTSTEPS

For anyone who would like to try this piece of music, there is a story in it. Heralded by a solemn knell, the gates of the underworld slowly open, culminating in a final crash. The Devil's heavy tread is first heard in the ninth measure. Beginning quietly, the footsteps come closer, gaining in volume and making the protagonist increasingly aware of the approaching danger. His apprehension is expressed by a leitmotif woven into the treble clef. At the end of the piece the large closing chord portends the very brink of doom. In the final part of this piece (not shown) the hero flees from his fate and escapes to a land of dreams.

The Devil's Footsteps

For Buttercup

Rowena

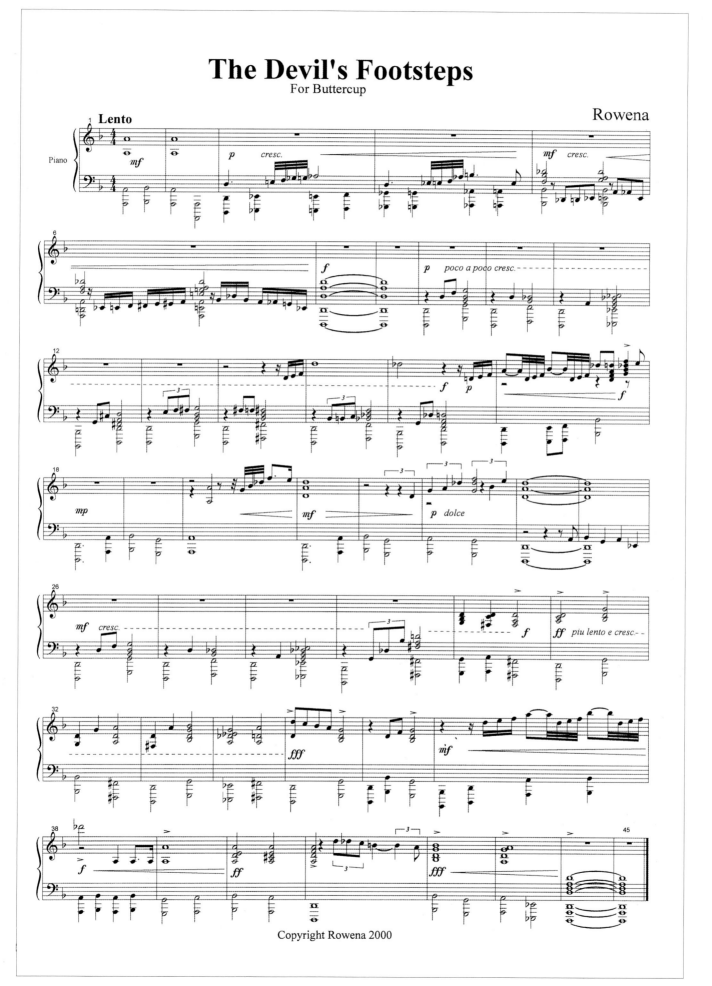

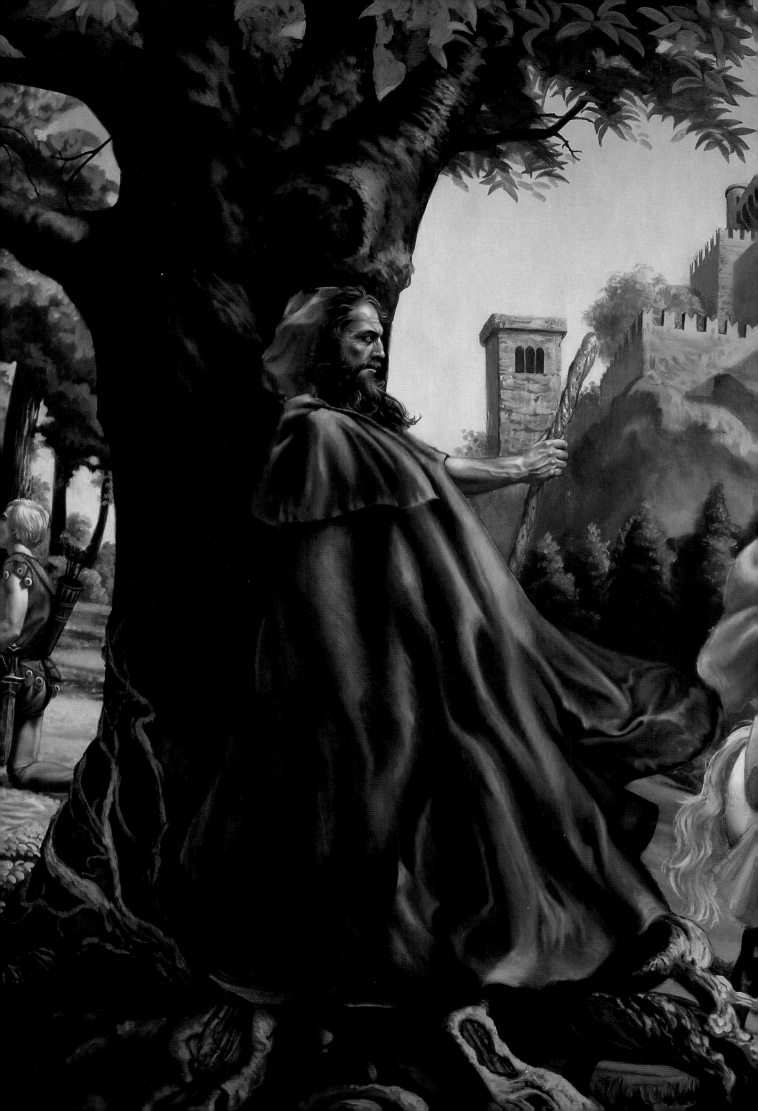

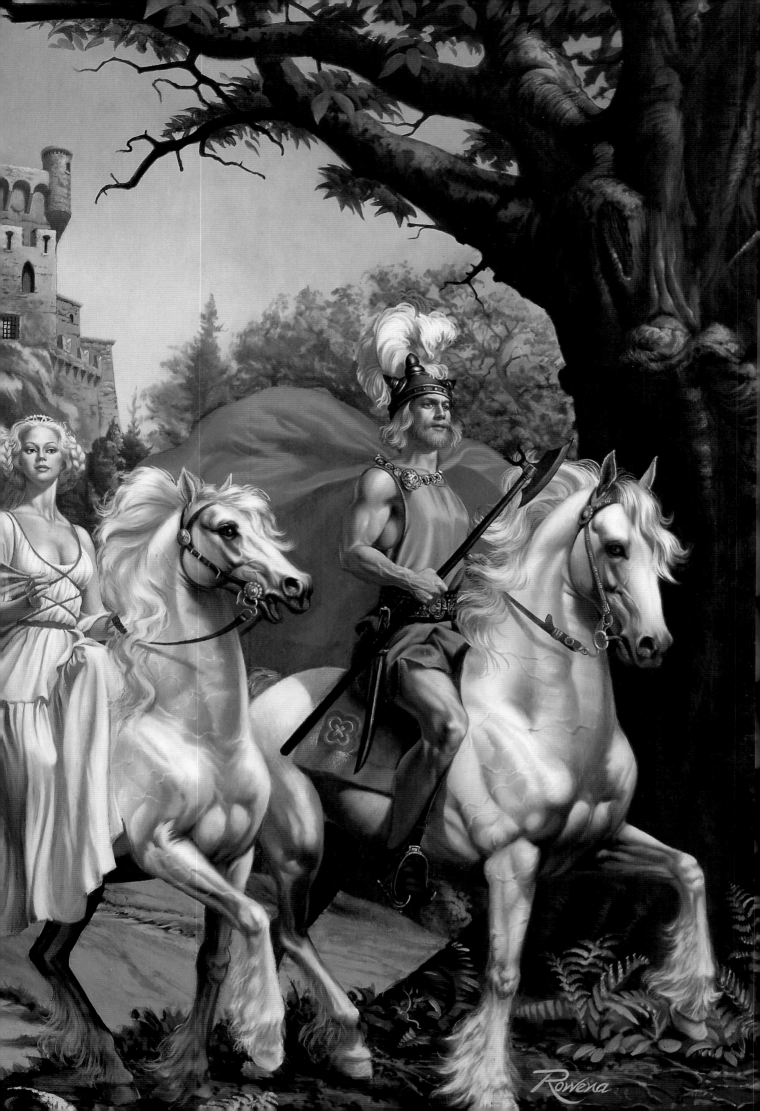

Rowena

BIOGRAPHY

ROWENA MORRILL, as I have come to know her, is a woman of many surprises, talents and moods. I had been aware of her work long before I met her, and was highly intrigued by her sensuous ladies, her beautiful, imaginative monsters and, not least of all, her exquisitely polished technique. I believe every painting is a form of self-portrait, whether or not that is the artist's intention. What I saw in her art was a rich inner life, the love of form and colour and, most thought-provokingly, the ability to depict the singular beauty that can be bound up with terror. For what distinguishes Rowena's monsters from all others is their fundamental beauty. I clearly remember the first time I met her. She wore her silky hair nearly down to her knees in those days. The intensity in her cat-like eyes gave the impression of keen attention to whomever was speaking and utter interest in what that person was saying. I was struck by the dichotomy of her demure manner coupled with her ready, unreserved laughter at the outrageous and at the absurdities of human nature – particularly her own.

We have been friends for over 20 years now, have spent endless hours on the phone together, and have borne frequent witness to each other's triumphs and despairs. What I treasure most about Rowena is her gift for putting a positive slant on things regardless of how grim they seem at the time. So, we were in the dumps over some romantic setback? There would be no wallowing in the slough of despondency. She would suggest an outing to the opera, a ski trip to Vermont, or, if

money was limited, an afternoon watching videos about women succeeding against all the odds. And always there would be the underscoring of our credo: *The only dependable solace lies in faithfully doing one's work, with all the struggle that implies.* What of material setbacks? Professional frustrations? Her resilience is marked by the conviction that periods of adversity promote the most growth.

Rowena happened into art by one of those strokes of fate that can make one believe in an omniscient and benevolent guide. No one in her family drew or painted. Her father was an army chaplain, her mother an accomplished pianist. One of her three sisters is an opera singer, and two grandparents were concert singers. Her mother cultivated the friendship of other good musicians and arranged regular evenings of live chamber music at the house. Considering how often the family moved, this was hardly an effortless feat.

Her father's career as an army chaplain demanded frequent relocations, and they lived in such far-flung places as Illinois, South Carolina, California, Japan, Indiana, Italy and Washington. While some children might have found this disconcerting, Rowena loved it. With each move she felt she was leaving all her cares behind, indeed soaring over them. There was also the endlessly exhilarating pleasure of the new. 'I could make friends in seconds,' she says of this period. 'On an army base, that's the rule, because every-body has always come from some interesting place and there's so much to talk about.'

It was in Japan that Rowena was first exposed to art. The family had a houseboy and two maids, who were enormously creative. By making glue from cooked rice, they could build an entire doll's house out of paper and paint it with watercolours. When Rowena was about six, the houseboy drew a pencil portrait of her mother, and that drawing made an indelible impression. The likeness was so remarkable in every detail, even to the shine in her mother's wavy hair.

Because of her family background, it would have been natural for Rowena to go into music. The nomadic existence, however, precluded any formal piano lessons until she was in her senior

Preceding pages:
THE CRIMSON CHALICE
VICTOR CANNING

The biggest effort I put into this painting, an early favourite of mine, was getting it back from the publisher. They kept telling me they hadn't finished with it yet. After many months of queries from me, the story became 'We can't find it. Maybe it is in the warehouse. Or at the printers.' A friendly art director finally told me that it had been given to a salesman as an incentive bonus! Armed with this information, I was able to lever it out of their grip.

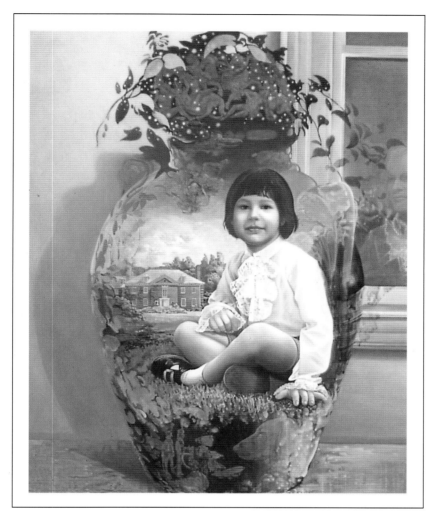

PORTRAIT OF ANTHONY
This was my first portrait commission, and was done in Philadelphia in 1976. At the time,
I was teaching myself how to paint and had a strong interest in surrealism.

year in high school. From the beginning, she practised diligently and became a music major in college. Alas, it became increasingly evident that no brilliant music career lay in her future. Those music students who distinguished themselves had all been child prodigies, already playing with symphony orchestras when they were nine years old.

With a pragmatism that typified her handling of disappointment, she decided to shift gears. The question was, what gear to shift to? Falling in love provided a handy answer, and after one year of college she married. Rowena's husband became an air force navigator, and spent a lot of time away from home. What might have been a lonely time for her became an ongoing frolic. There were bridge games with the other air force wives, parties every weekend, and the wonderful military tradition of 'happy hour' every night. But the futility of a directionless life can darken even the brightest days.

It was at Beale Air Force Base in California that everything changed. Whether out of curiosity or merely by chance, Rowena happened into the local hobby shop just as a drawing class was in progress. Although the class had started some weeks earlier, she convinced the teacher to let her participate. With no greater ambition than to pass some interesting hours, she sat down with a pencil, paper and eraser to draw the still life that had been set up. As she tells it, she drew and erased, drew and erased, drew and erased some more. At the end of two hours she had completed a photographic likeness of the still life. Everyone in the class, including the teacher, gathered around to admire it. She had never received so much positive attention. In her own words, 'It was like getting a big shot of the most addictive drug known to man.' From then on, she drew everything and everyone who held still long enough. She drew in every spare moment.

After nearly a year at Beale, Rowena's husband was relocated to the east, and she entered the University of Delaware as an art major. Sadly, the marriage dissolved during her first semester. Undoubtedly the wandering existence she had

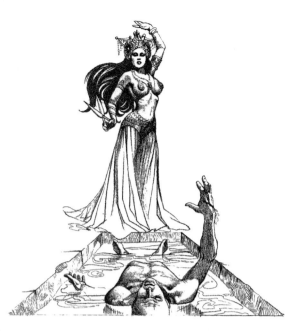

led made it hard for her to look upon anything as permanent.

Rowena regarded New York as the Mecca for artists, and every move after graduating from university was designed to take her there. As a stepping stone, she settled in Philadelphia for a while. Having lived on army posts most of her life, it was a big city to her. Although she now had a BA in art, she still needed to study more in order to become proficient at drawing and painting. The life sketching classes in college had been simply 30-second 'gesture' drawings, done with an enormous piece of charcoal. Such poses were insufficient to complete a realistic figure drawing. Rowena began to take night classes at the Pennsylvania Academy, where the models assumed longer poses. She also hired models from the Academy to come to her home so that she could practise life drawing. She found a part-time job at an art gallery that gave her enough money to cover her expenses *and* paint on the side. She studied advertisements for artists. The first one she answered was for an in-house artist to make catalogues for a manufacturer of aeroplane parts. With no comparable experience whatsoever, she was plainly unsuited for the position. But, after the

AND ETERNITY
PIERS ANTHONY

As a child, when I dreamt of being in the movies, I always wanted to be the bad girl. The whole concept of a naughty girl who plays by her own rules and doesn't follow the herd is just so full of possibilities. The model who posed for this painting was nothing short of a riot. She didn't need any guidance at all to get into the spirit of the thing.

interviewer had looked at her portfolio, he hired her to paint portraits of his children. Other portrait commissions followed and soon the time seemed right to chance an art career in New York.

Rowena's first job was in a small advertising agency, doing anything that was needed: layouts, photo retouching, mechanicals, even an occasional drawing. She hated the place and moved on to a better advertising agency, where she was guaranteed six weeks of work, more if the agency retained the particular account she was to work on. Rowena was unaccustomed to thinking much beyond the immediate present, but six weeks later she found herself out on the street, and that got her attention in a hurry. Since she had done large air-brushed paintings of animals for an interior designer in Philadelphia, she went through the *Yellow Pages* calling interior design firms, architectural firms, comic-book houses and small publishers. Tackling the list alphabetically, she made an appointment with the art director at Ace Books. Her realistic paintings of the human body were exactly what he wanted and she was immediately given a book-cover assignment.

Fortune smiled on Rowena in New York. She could be walking down the street with her portfolio or standing in an elevator when someone would ask if she was an artist. She would end up showing her work in a lobby, on a street corner, even on a subway platform. Inevitably, a commission would follow, or else a lead to see an art director, which would result in a commission. She was unique in the fantasy field when she

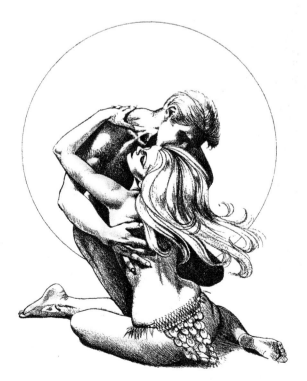

started in New York; the only woman producing exciting, realistic, believable paintings of heroes and heroines, monsters and villains.

As Rowena's career flourished, her daily life became topsy-turvy. The weeks of working sixteen to twenty-hour days left little time for the simple pleasures of taking a shower or even eating properly. During that period, some of her best friends were the Chinese-food deliverymen.

Once she was established, life became slightly more normal. A personal friend who taught at the University of Delaware recommended her as a teacher, and she welcomed the change of pace. It added a new dimension to her professional life and a revitalized energy for her work. For two years she rose at five a.m. once a week to catch a train out of Manhattan to Dover, New Jersey, where she taught at the Joe Kubert School of Cartoon and Graphic Art. The necessity of clarifying her ideas so she could articulate them to her students put them into perspective for Rowena herself and gave them new import. It increased her interest in her own work, and made her eager to inspire every one of her students to do the best work they were capable of.

Oddly enough, throughout her years of painting, Rowena had never worked on anything that was not either a school assignment or a commissioned piece. True, the existence of a deadline is a highly motivating factor, just as the lack of one can lead to interminable procrastination. But, aside from the pressure of deadlines, it simply had not occurred to Rowena that she wanted to do paintings based on her own fantasies and philosophies. The constraints of having to earn a living made it seem impractical to paint solely for her own pleasure.

Providentially, publisher Michael Friedlander offered her an exciting project: 20 paintings of whatever she wanted to paint, as long as it was related to the fantasy genre. They were to be used for trading cards, calendars, and ultimately a book of her work. Appealing as this venture was, the unlimited freedom was also daunting. Several months of self-searching went by. 'What do I want to do?' she wondered. After much, dallying and wheel-spinning she filled an entire notebook with thumbnail drawings of different ideas. The more she sketched, the more ideas she got and the greater her enthusiasm became. Unfortunately, halfway through the undertaking, Friedlander's publishing company went bankrupt due to business reversals out of his control. Thus ended the wonderful project. Despite the weighty disappointment, the experience benefited her enormously, providing her with renewed artistic focus and passion. She *needed* to go on producing 'personal paintings'. With this in mind, we have been planning to do a second book together, one of stories that I will write and she will illustrate.

For most of us the question eventually arises: What would I do differently if I had my life over again? Sometimes Rowena regrets having started in art so late. As with her first still life, which required so much erasing and redrawing, the process of 'getting it right' might have been facilitated by an earlier start. On the other hand, how many interests would she have failed to develop had she gone down that path?

As a child, she loved climbing trees and running. She could outrun anyone in the Japanese

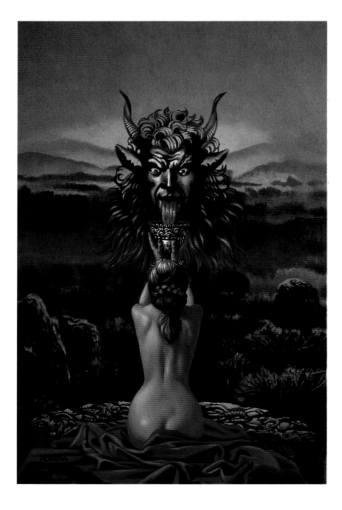

ISOBEL
JANE PARKHURST

This was my very first fantasy book cover. I clearly remember going to the bookstore, seeing it on the shelf, and being absolutely thrilled. I was chosen to do this piece specifically because of my college portfolio of fanciful, surrealistic paintings, as well as my portrait work.

'GUARDIANS' GAME CARDS
FRIEDLANDER PUBLISHING GROUP

This was part of a group of quick and fun paintings I did based on other people's concepts.

grammar school, and wrestle any boy there to the ground. The result of this physically active beginning was to inspire a love for sports. Running is still a daily must. She is also an enthusiastic mountain and rock climber, skier, swimmer, scuba diver and sailor. Five years ago she switched from large sailboats to high-performance dinghies and skiffs. The first of these, a Laser II, had a tiny body about the weight of an eggshell, made top heavy by very large sails. It needed one person at the tiller and one (known as 'the crew') on the trapeze to lean way out over the water and balance the boat. Wearing a harness with a wire from her waist to the top of the mast, Rowena was the crew. With her feet on the edge of the boat, she would lean back until she was nearly parallel to the water. She speaks with obvious pleasure of the adrenalin rush she got by zooming along with huge waves slapping at her back.

Finally, there is her love and appreciation of music, which she might never have developed to the extent she has. Now, whole afternoons can be spent at the baby grand Mason and Hamlin she adores, in order to work on one of her many compositions. While it often seems to her that it must

still be afternoon, a glance at the clock can reveal that it's five a.m.!

The success of an artist can be measured by many yardsticks. Critical acclaim, the easiest of these, is also the most transitory. Tastes change. Fashions change. It could be argued that the intrinsic value of any art lies in the impact it makes on the viewer. Yet, more significantly, its value is determined by the enhanced sense of purpose it lends to the artist's life. No true artist is ever fully satisfied, but dissatisfaction is a blessing. It is what keeps them exploring and gives them the courage to embark on what is, in fact, a spiritual journey. By these criteria Rowena can definitely be judged a success. Today, she lives with her friend, Fabio (an electrical engineer, not a model), in a flat overlooking the ocean. She begins the day with a four-mile run along the beach, followed by a luxurious swim in the waves. It is here that the storms as well as the sunshine grant their measure of guiding inspiration for her work.

Doris Vallejo
West Orange, New Jersey,
November, 1999

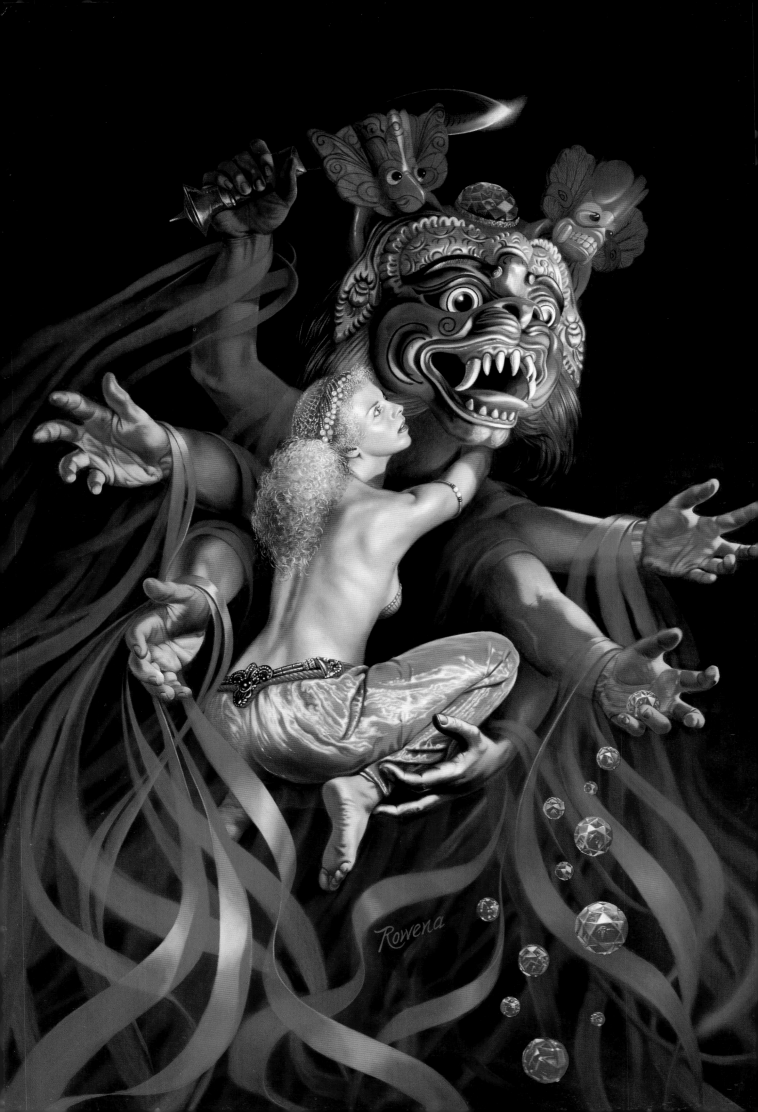

PERSONAL PAINTINGS

CRIMSON DEMON

*I*n Indian and Asian art, male gods are frequently shown with their female counterparts in what is called the 'Yab Yum' position. The woman is clinging to the man in a seductive way as he dances wildly. Although the Yab Yum position has different shades of meaning for different deities, it is generally accepted that the male god represents power and energy, whereas the female exemplifies composure and serenity. Legend has it that the male can exhibit states of uncontrolled energy which, left undirected, will become destructive. When the female unites with him, that energy is balanced. Together, the two establish harmony, creativity and fulfilment. I compare them to electricity, which has both a positive and a negative charge, coming together to create light.

These dynamic figures with their human bodies and non-human heads have always fascinated me. I use them as inspiration for depicting my own conception of archetypal males and females.

Following pages:
PERMETTE SIGNORINA?

*T*his was purely a whimsical idea – no weighty message was intended. I wanted to play with the fact that a painting only has two dimensions and yet it can give the illusion of a three-dimensional image. It amused me to take liberties with the surface of the water, transforming it into shattered glass and creating a portal to another world. Behind the curious fish anything could be lurking beneath the glass veneer. I will leave it to your imagination.

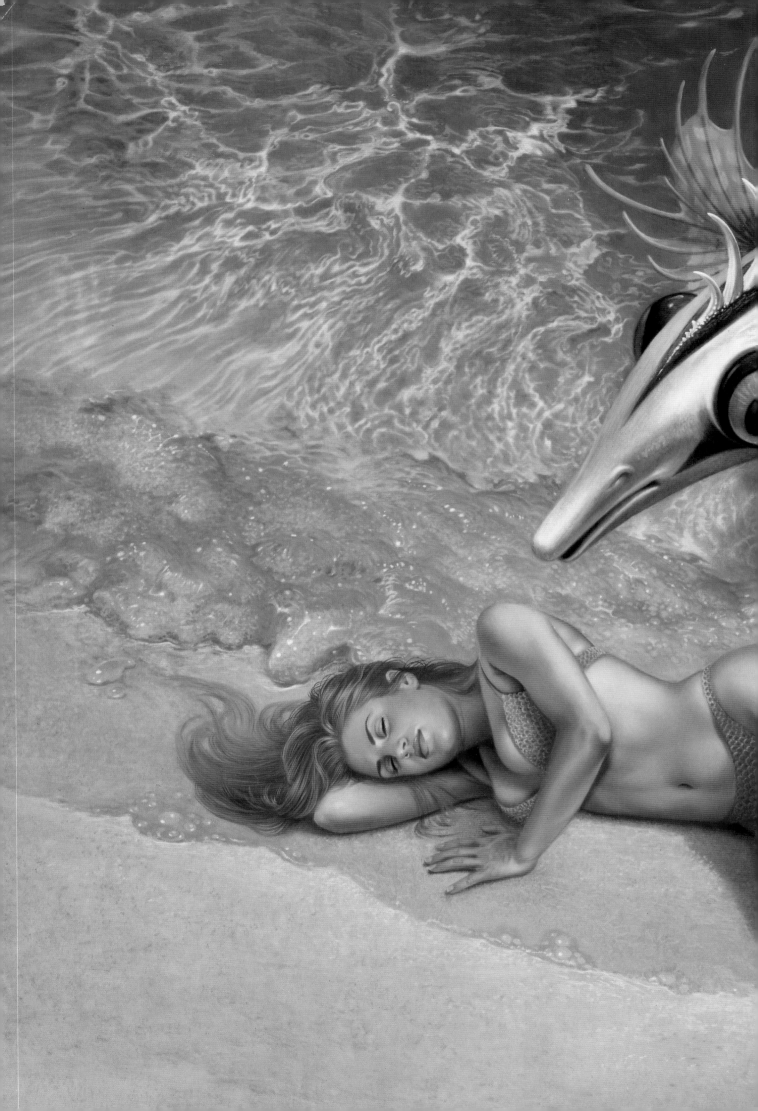

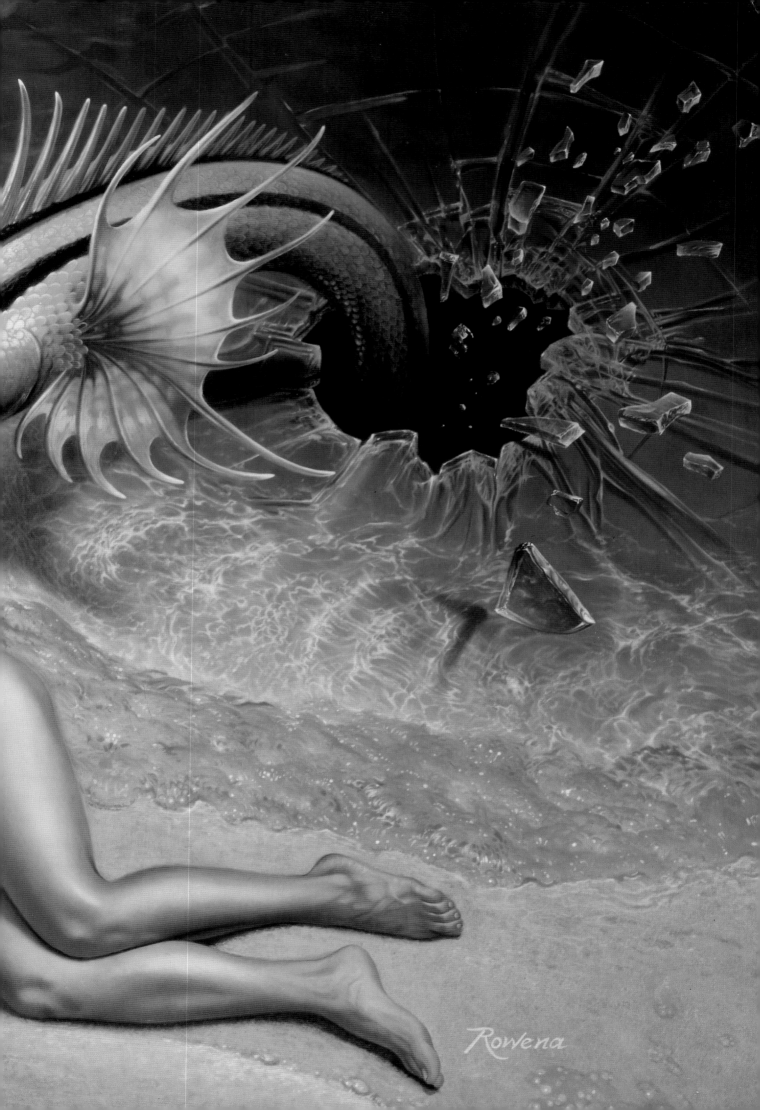

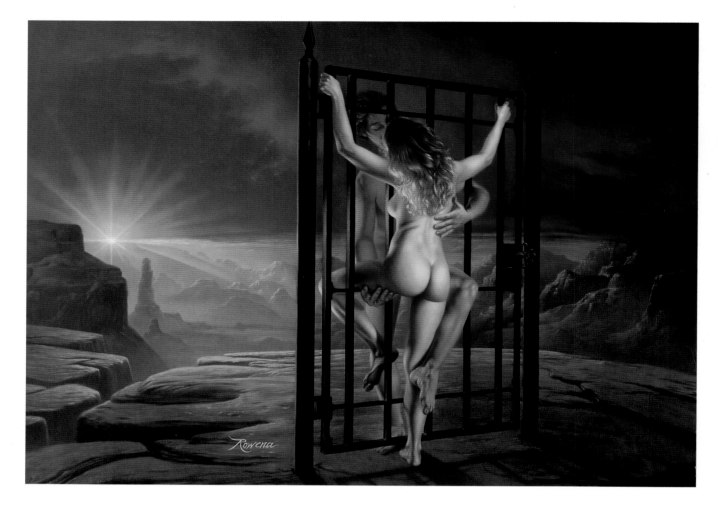

THE GATE

I have often been struck by the fact that the very obstacles in a relationship can be what keep people so locked into each other. It is perverse to stay fixed on the precise spot where the impediment is, blind to any obvious way around it. I wanted the setting to be very emotional, bathed in the golden rays of a sunset. Some of my friends have discovered all sorts of phallic imagery in the background.

I personally find all art forms – dance, music, literature or painting – hard to relate to if they are devoid of sensuousness. Art that is purely intellectual holds very little interest for me. I love the romantic musicians, Brahms, Chopin, Rachmaninov. Even unintentionally, that comes through in my work.

Right:
STONE DEMON

I was fascinated by the wonderful carved stone statues I saw on my trip to India. They were fierce and exotic; there was nothing classical or subdued about them. The idea was to have a multi-armed stone creature in a wild uninhibited dance pose, juxtaposed with a human girl limply draped over one thigh. This is also my expression of the seductiveness of power. The statue is God-like and the girl is captivated by his mystical omnipotence.

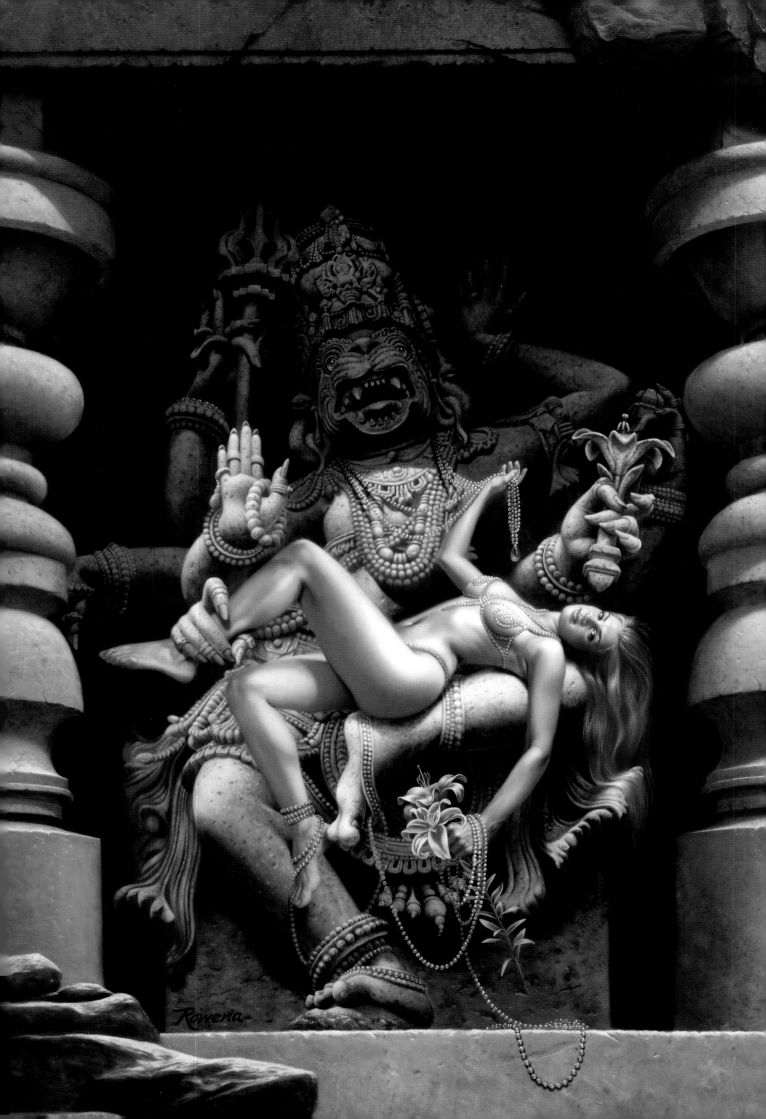

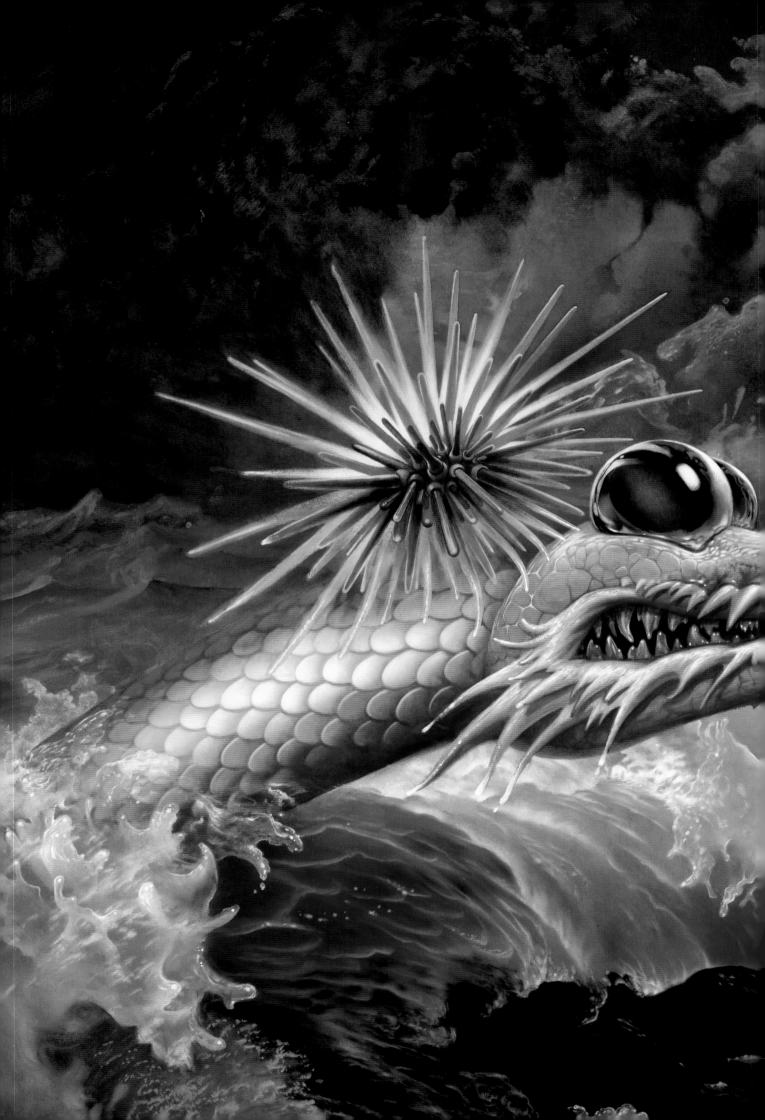

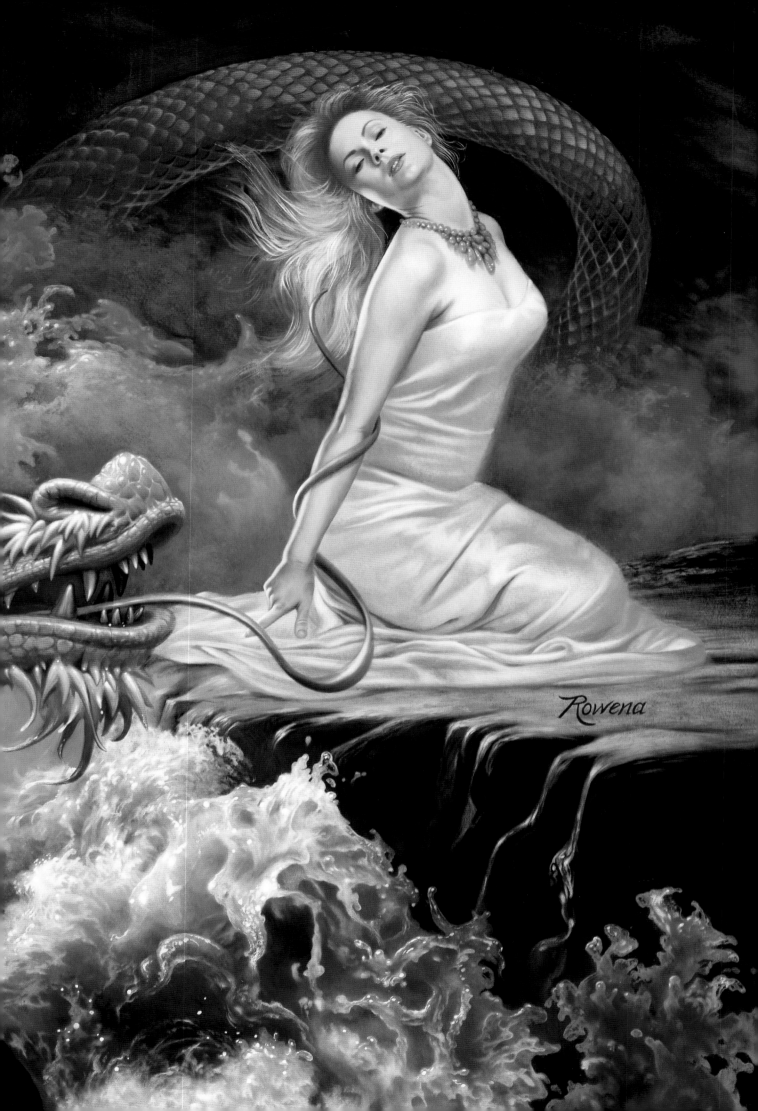

Preceding pages:
DRAGON'S SERENADE

*T*wists on the commonplace and the categorically accepted appeal to my sense of humour. This lady is hardly threatened by the sea monster that surfaced while she was sunning herself on the rock. Quite the contrary, she is flattered by his attentions and tickled by his long tongue as it wraps around her arm. No doubt, she will make a pet of him.

My favourite part of this painting is actually the water. I wanted it to look forceful and unconstrained. I must have succeeded because I'd love to dive into it.

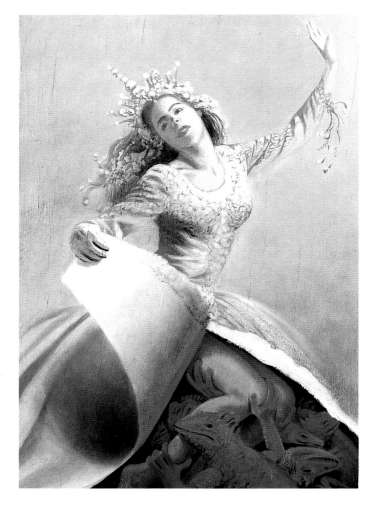

Above:
UNPUBLISHED SKETCH

Right:
FORBIDDEN FRAGRANCE

*T*he bottle is heart-shaped, signifying that this little demon lives in the lady's heart; she treasures him. The idea came to me because I have my own little demons. Often, I hold on to them because they are a wonderful source of energy when my spirits are flagging.

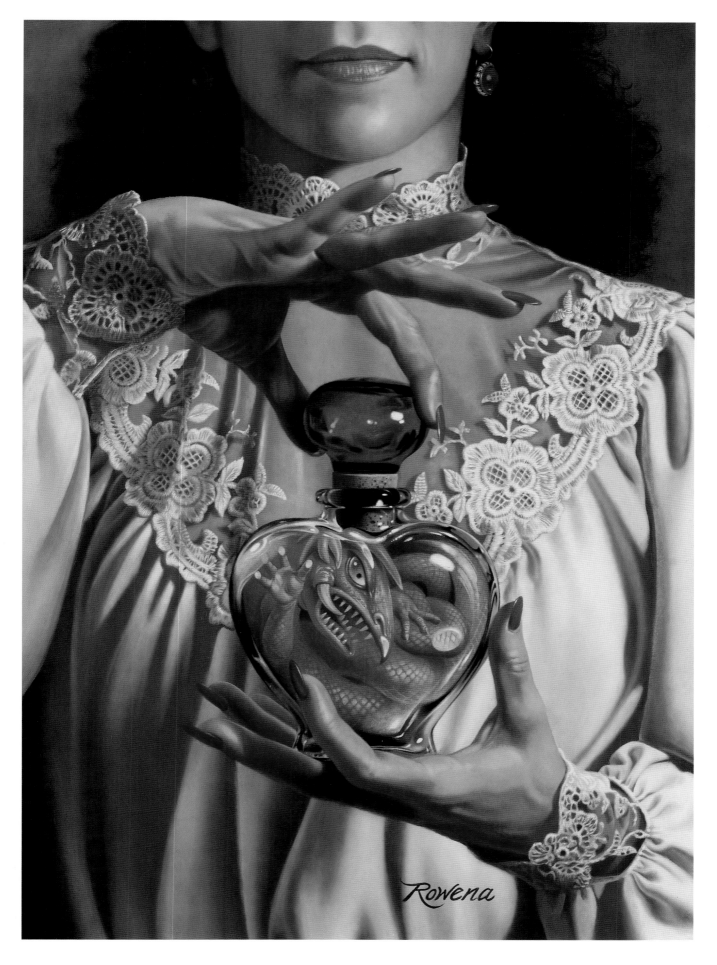

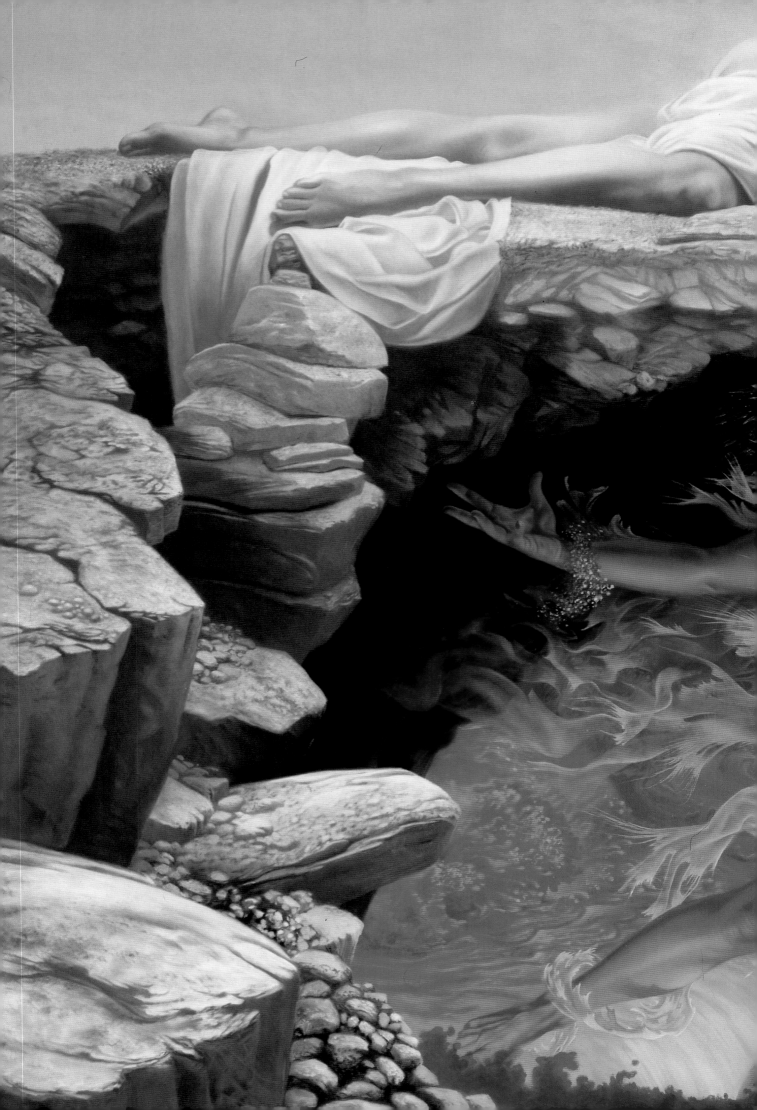

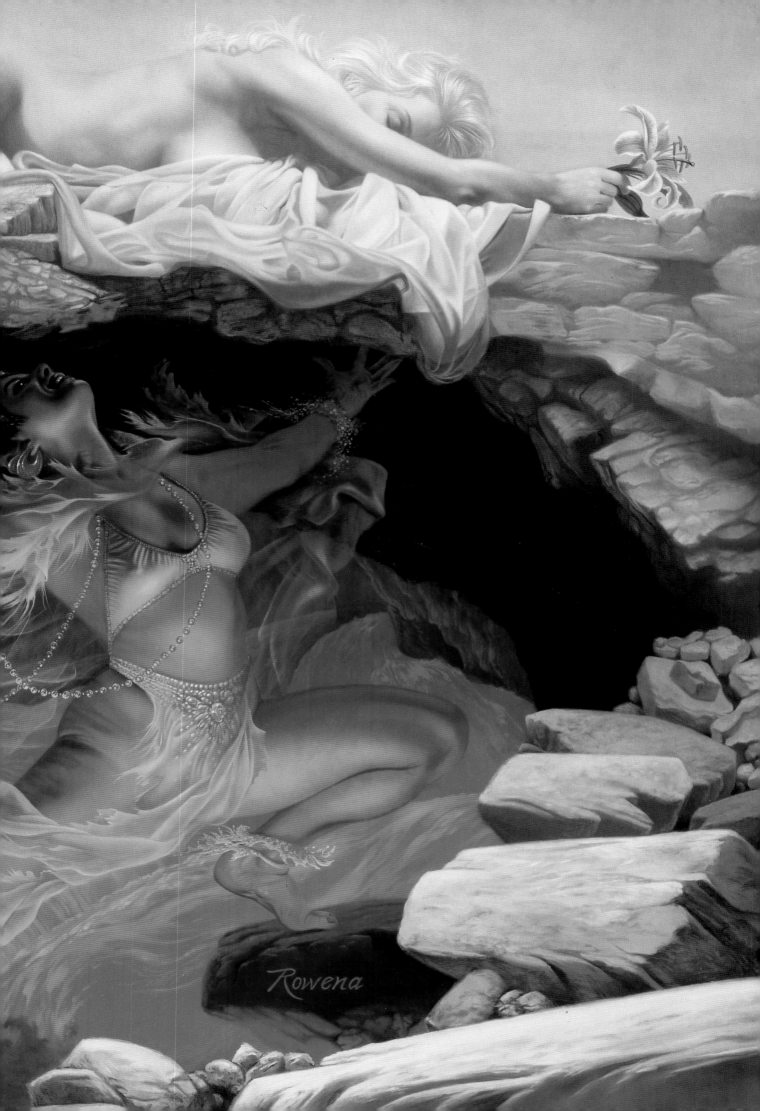

Preceding pages:
THE LAVA PIT

*H*ere, my theme is the paradoxical extremes of human nature: the most abandoned expression of emotion encased in rock-bound languidity. The scene inside the lava pit is done in red and orange, boiling hot, whereas the outer part is all cool blues and greys, with just a suggestion of passion in the pink lily. On the surface the quiescent girl is placidly unaware of the tumult raging below.

Right:
WATERFALL

*T*his is another play on the theme of opposites. Both women spring from the same source, but one is drawn toward the light, the warmth, the bright flowers, while the other just as eagerly takes the darker path. I was reminded of the Robert Frost poem, 'The Road not Taken', which begins: 'Two roads diverged in a yellow wood, And sorry I could not travel both...' These women, alter egos of the same persona, are therefore able to take both roads, make both choices. The darker path may be more dangerous, more the way of the rebel. Yet it has its own appeal, quite equal to that of the sunnier, more accepted way.

Following pages:
THE MERMAID'S TALE

*H*er tail is very long. It recedes into the background, wraps around itself and coils into the foreground again. It is not immediately apparent that the tail ends in the monster's head. He is actually part of the mermaid. She is hugging and caressing him, and clearly loves him. I had two points at issue when I conceived this. The first was to create a depiction of narcissism. The second was to make a statement about the vast contradictions that can exist within the same human being. In a somewhat narcissistic way, the mermaid is embracing the wild side of her nature.

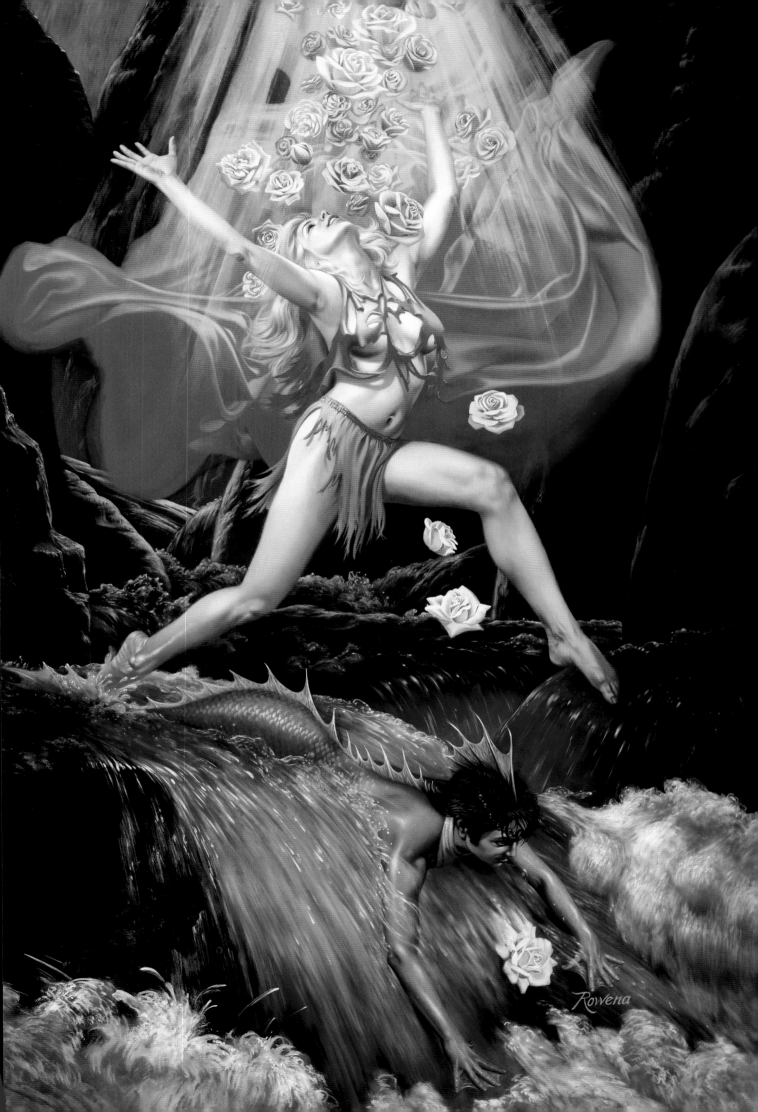

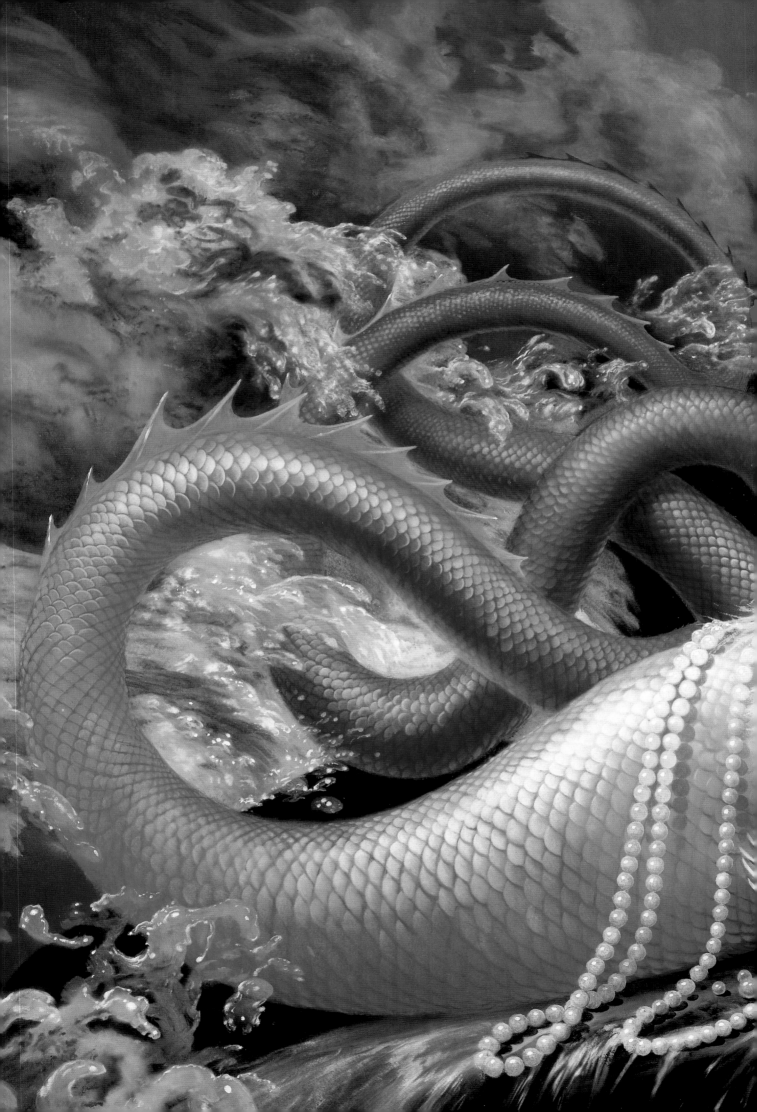

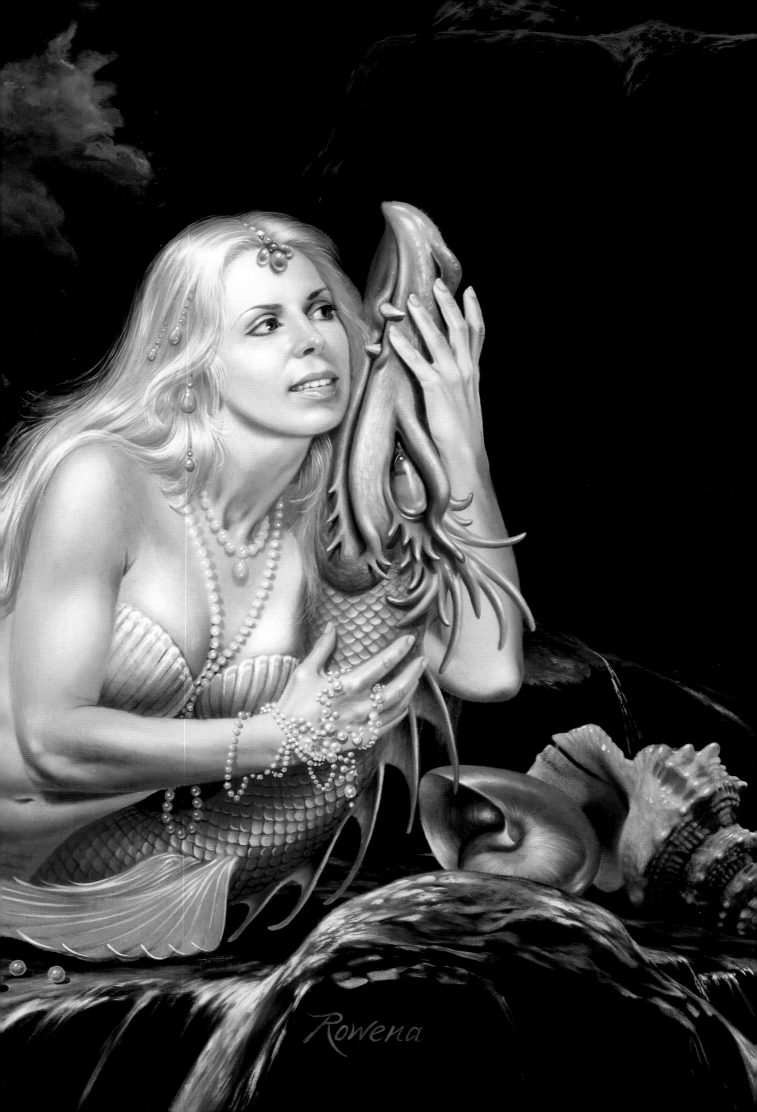

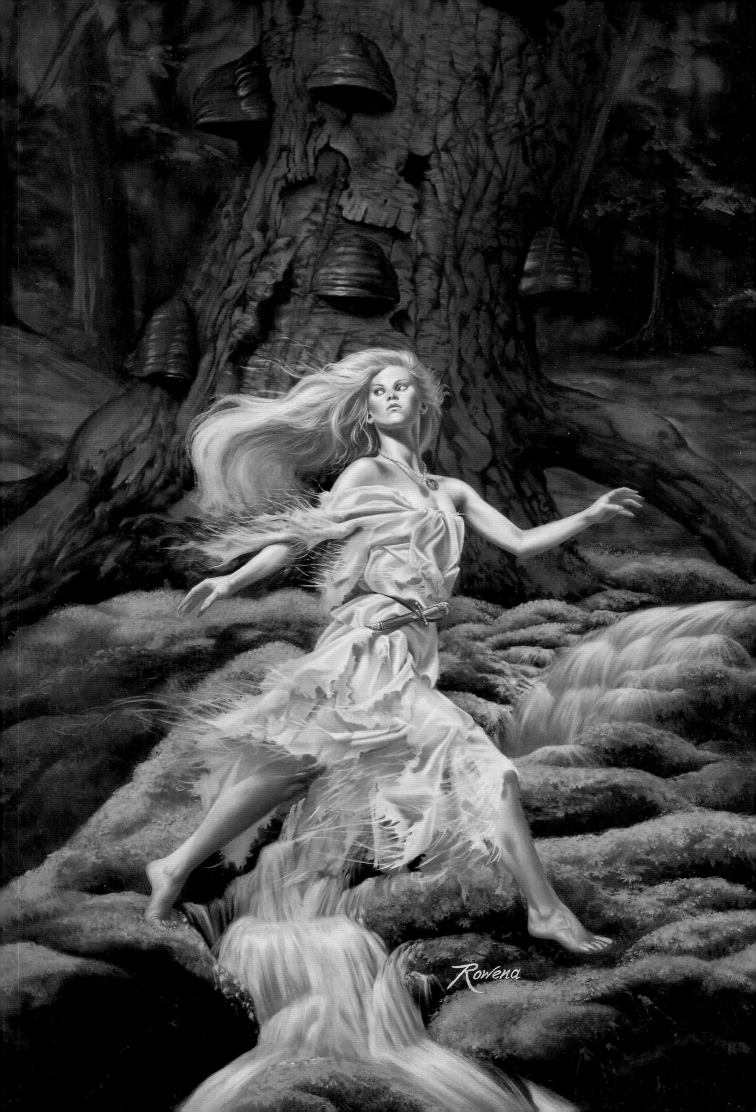

Book and Calendar illustrations

I had been boating on Lake George and stopping occasionally at one or another bank. At one of these stops, I saw a wonderful waterfall cascading over the mossy ground, and I just had to disembark to touch it. The moss felt so clean and fresh under my hands, and the water was incredibly clear. The photographs I took there were the perfect reference when this painting came along.

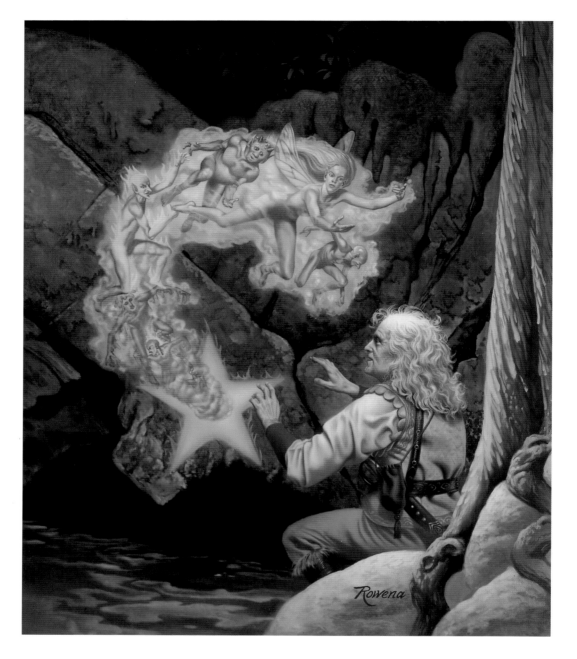

DAGGERSPELL
KATHARINE KERR

*A*t times I find it difficult to do a painting within the strictures of someone else's ideas. I loved the thought of a magical occurrence in the woods, but felt confined by the description of the old man and his clothes. They were so far from my own ideas of what this old man should look like.

Right:
CRYSTAL LINE
ANNE MCCAFFREY

I found the colour of this ski suit so exciting, I *had* to buy it. But when I modelled it for a skiing friend, he laughed uproariously. In his opinion it was garish, and he didn't hesitate to tell me what bad taste it would be to wear it on the ski slope. I wore it anyway, with great pleasure, and was complimented on it. It also came in handy for my work, and I have used it more than once as an outer-space costume for a book cover.

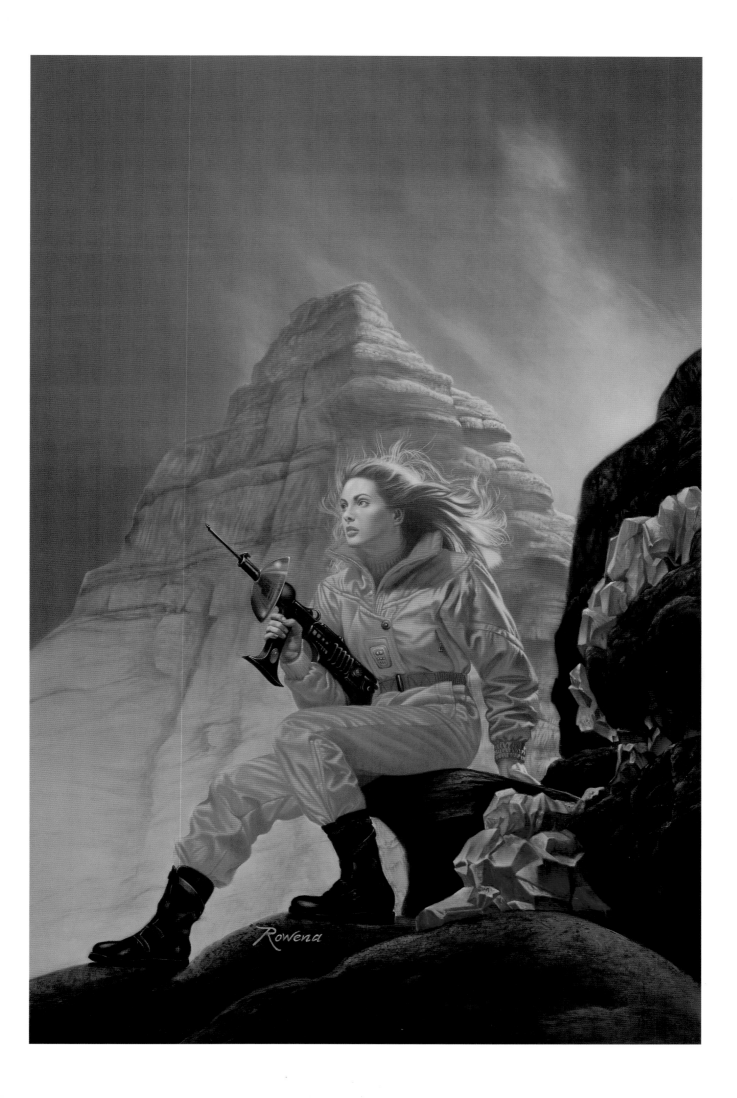

MARTIN BEAR AND FRIENDS
THOMAS HAUSER

*T*om Hauser and I met while running in Riverside Park. We both grew up reading the wonderful children's classics illustrated by Howard Pyle and N.C. Wyeth. Although he had been extremely successful with books such as *Missing*, from which a big-name movie was made, as well as two books on Mohammed Ali, Tom wanted to write the sort of fairy tales he had loved as a child. When he suggested that I do the illustrations for his book, I could not have been more pleased.

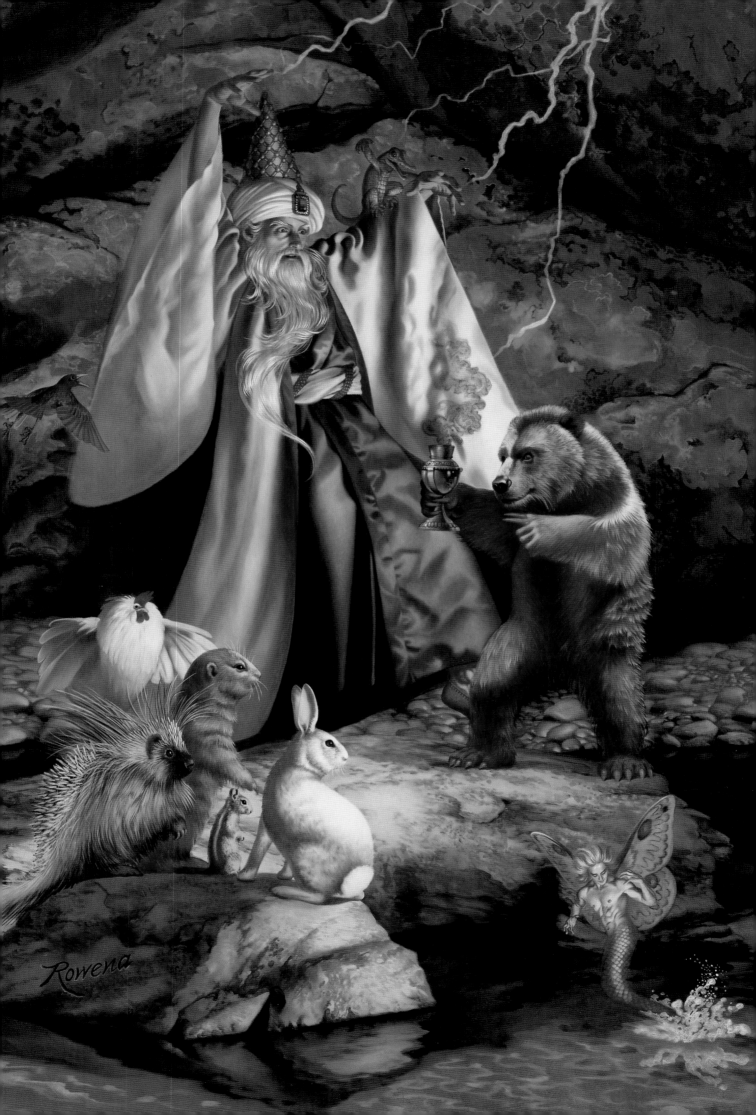

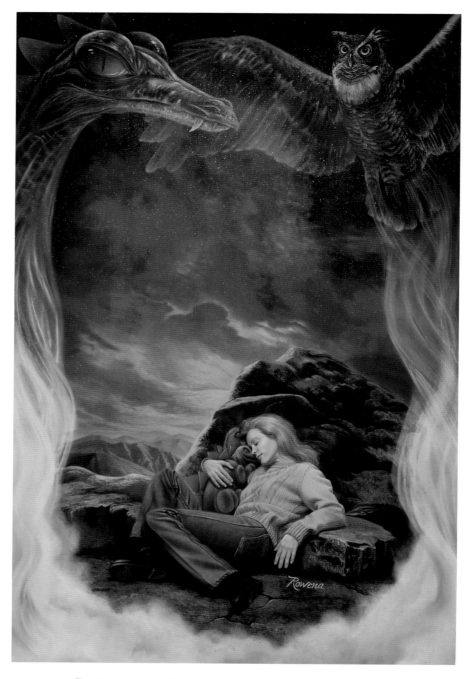

BROTHER TO DRAGONS, COMPANION TO OWLS
JANE LINDSKOLD

*T*his little girl and her benevolent dream figures present a wholly non-threatening atmosphere. As such, the illustration differs significantly from most of my paintings, and no doubt because of this it is one of my mother's favourites. 'Oh what a sweet painting,' she said when she saw it. 'If only you would do more like that.'

Right:
DOLPHINS OF PERN
ANNE MCCAFFREY

I talked to Anne McCaffrey personally about how her dragons should look and used this painting as an exercise in faithfully adhering to her descriptions. As for the boy riding the dolphin, I assumed he would be holding the fin with both hands. In fact, the boy who modelled had ridden a dolphin in Florida and corrected me. That was a lucky break, because I would have shown him in the wrong position.

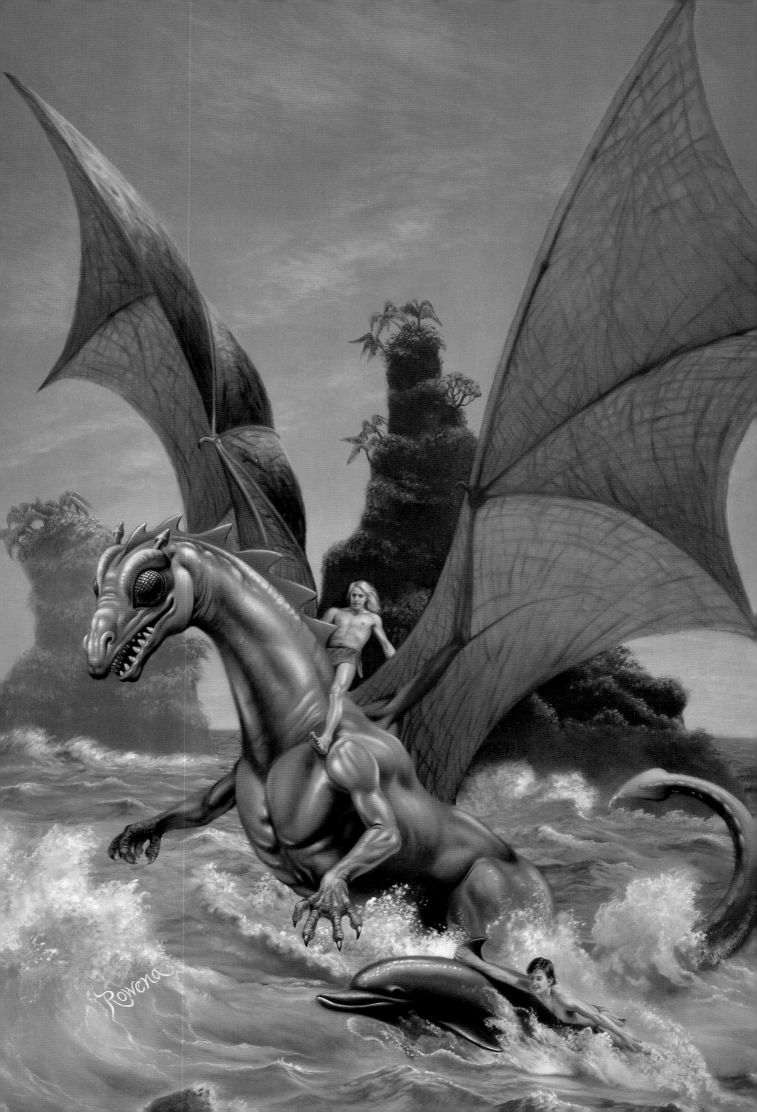

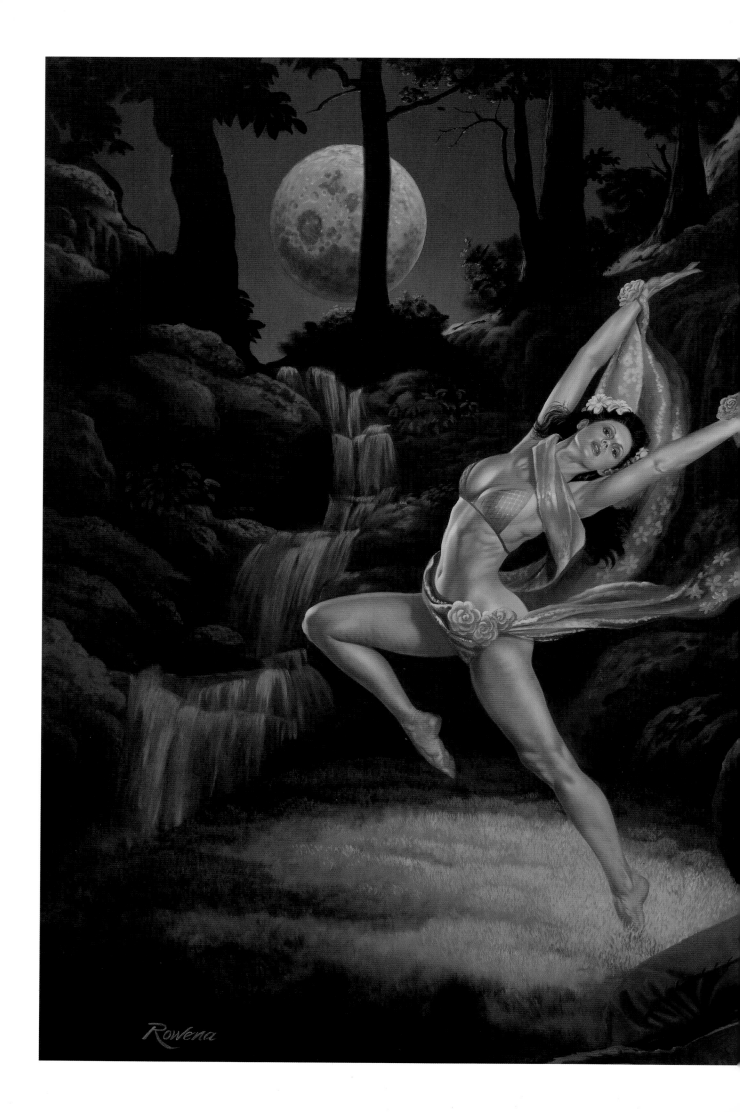

BEREN AND LUTHIEN
TOLKIEN CALENDAR

I love the sounds and smells of the deep woods. I adore the feel of moss under my bare feet. And who could not enjoy a full moon? For me this is such a happy setting. It is a place where I would like to be and where I too would dance out of sheer pleasure. I sought to express that exultation and sense of freedom in the figure of Luthien.

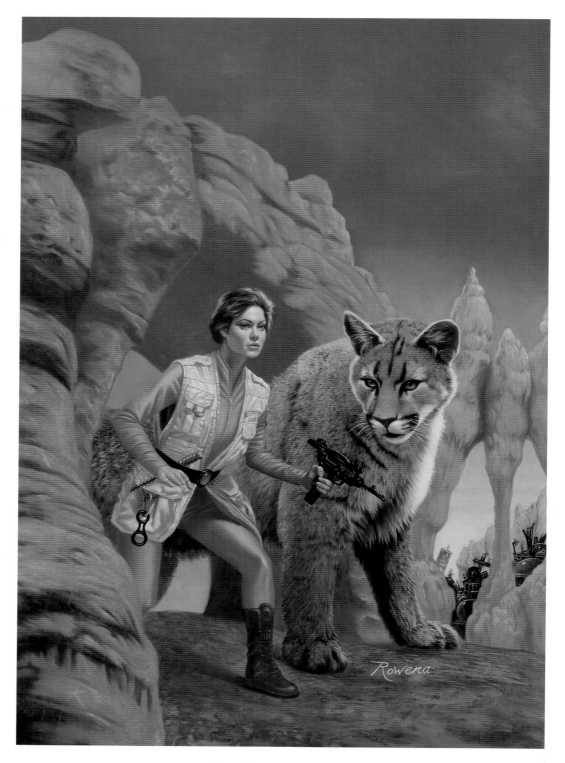

CAT SCRATCH FEVER
TARA K. HARPER

I had just been to Bryce Canyon in Utah, and had fallen in love with the magical rock formations. It was a joy to be able to use photographs from that trip as references for this painting.

Right:
BYZANTIUM'S CROWN
SUSAN SHWARTZ

*T*he mystery, majesty and colour of Egyptian imagery have always appealed to me. As such, the components of this painting fell into place easily. It was an added bonus that the very agreeable model posed for all three female figures.

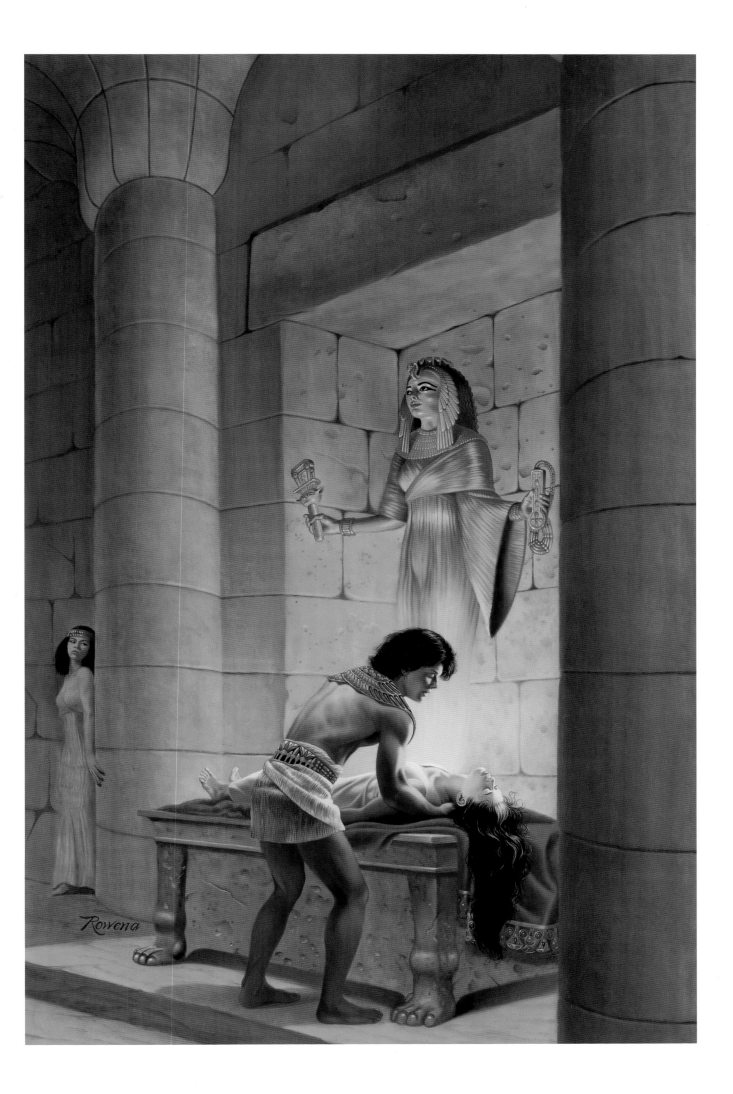

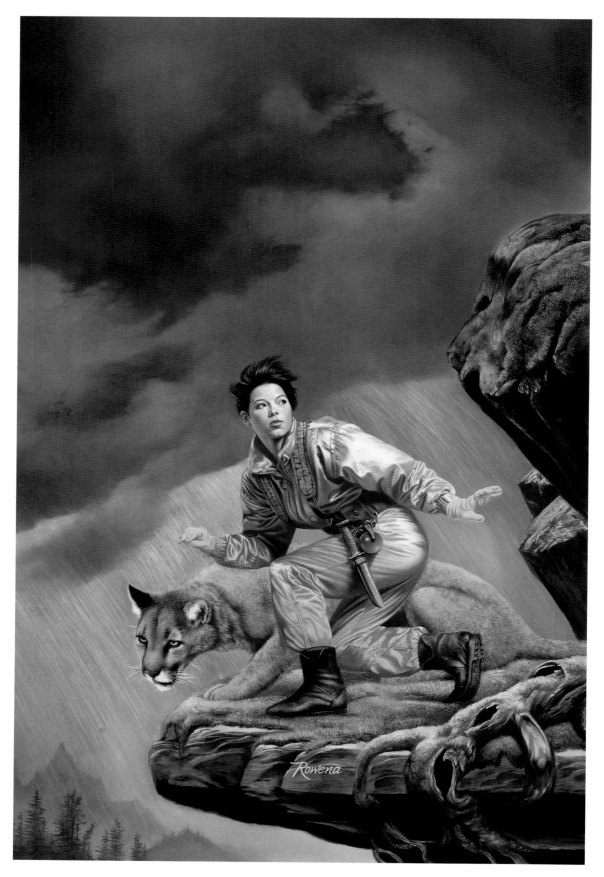

CATARACT
TARA K. HARPER

This is another in the series of authoritative women taking action. I got great pleasure from using my favourite ski suit in a painting.

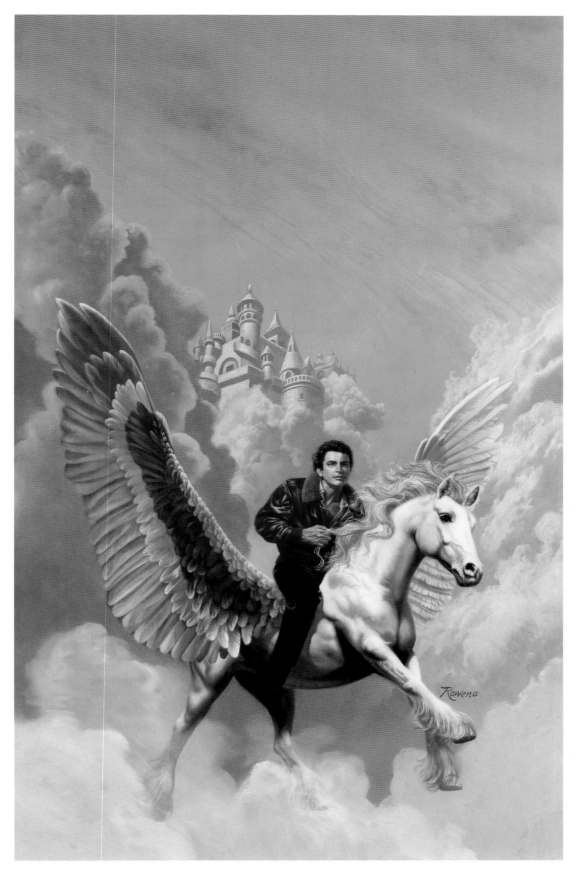

CLOUD CASTLES
MICHAEL SCOTT ROHAN

*W*ho wouldn't love a castle in the air? I think that image must be universally attractive, but I found it jarring to put a contemporary man into such a fantastical setting.

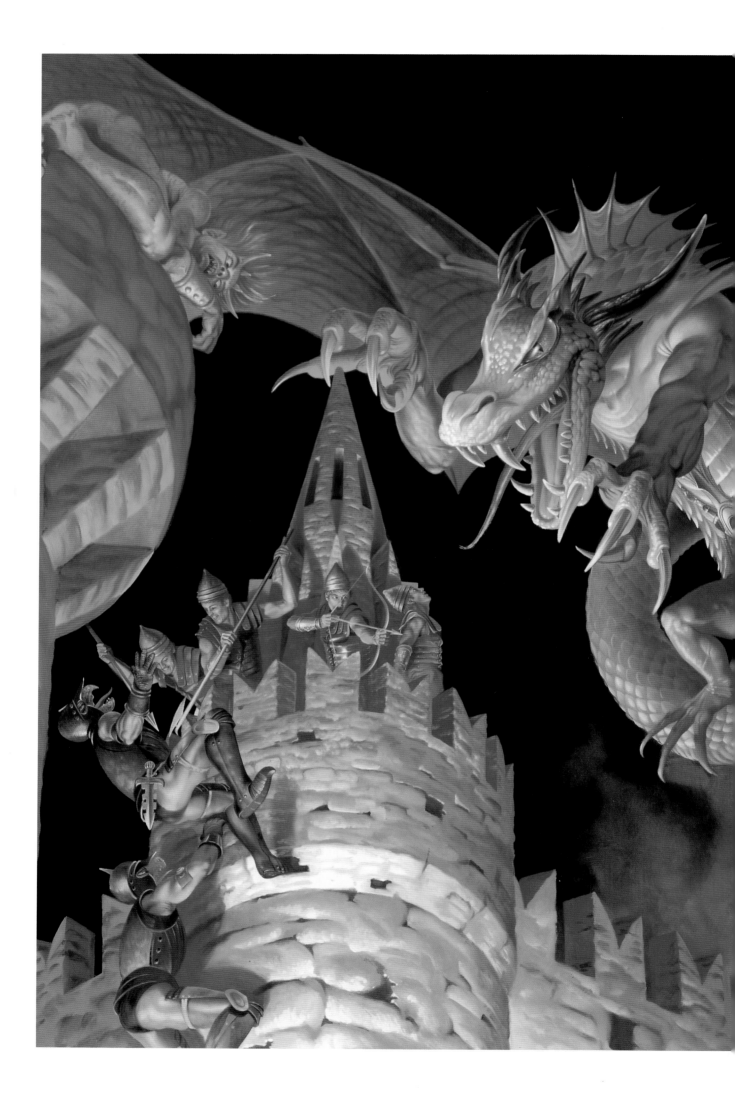

Rowena

THE BATTLE OF SUDDEN FLAME
TOLKIEN CALENDAR

A golden dragon decorated with jewels is another of those images that echoes from my childhood. I particularly love dragons and, because I have never thought of them as evil, I purposefully make them grinning. I certainly did with this one. One could say that the dragon is happy because he enjoys attacking these men. But that would put a negative slant on the picture, and it is not what I had in mind. Rather, I see a game of strategy – not unlike chess – going on here. At this point, the dragon is winning, and naturally he is pleased.

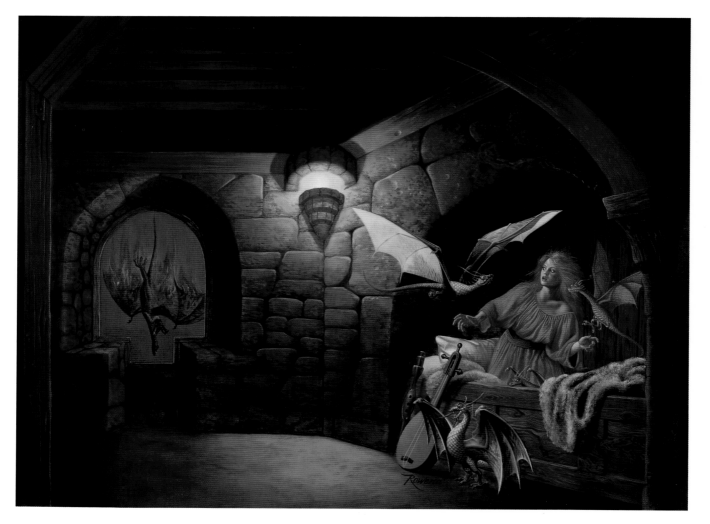

DRAGONSINGER
ANNE MCCAFFREY

*T*his was an unusual heroine for an Anne McCaffrey novel, in that she was not an obviously dominant female. The premise here was that these dragons were her pets and she could communicate with them.

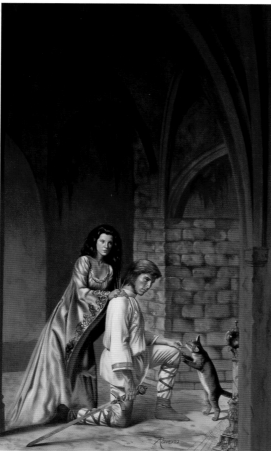

Left:
THE SWORD OF CALANDRA
SUSAN DEXTER

*T*his time my cat, Dandelion, was pressed into service as a model. He was the sweetest cat in the world and loved being petted. As soon as I grabbed his paws to pull him up into position on the 'knight's' thigh, he would sag to the floor, expecting to have his tummy rubbed. We finally hit on the idea of luring him into position by holding up one of his favourite treats.

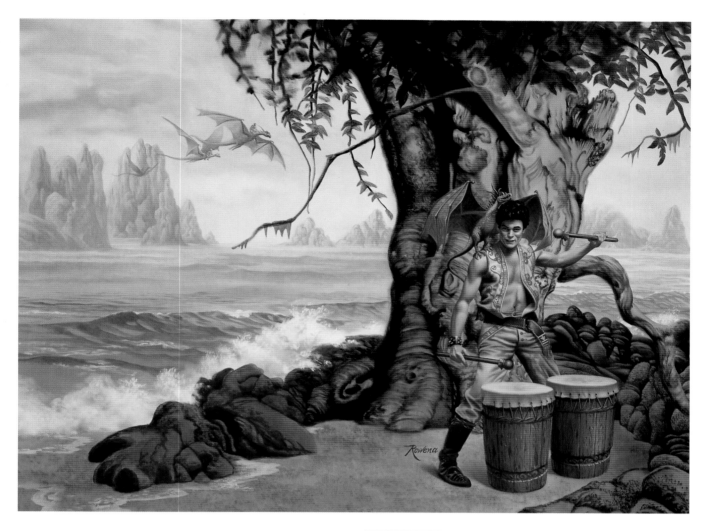

DRAGONDRUMS
ANNE McCAFFREY

*T*he premise of this novel is that certain dragons can bond with special people. I wanted to make the dragon on the drummer's shoulder look as though he was savouring the drumbeat through and through, like people I've seen in jazz concerts.

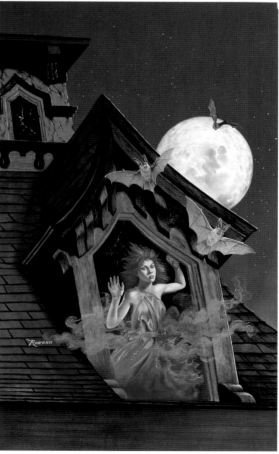

Right:
THE HAUNT
JOHN FOGARTY

*T*o me, the basic elements of a haunted-looking house are cobwebs, bats and a full moon shining from above. Naturally the girl who finds herself there is terrified. I certainly would be, and it wasn't hard to empathize with her.

Flight from Nevèrÿon
Samuel R. Delany

*S*ince I had gotten friendly with Samuel Delany at science fiction conventions, I was happy when he called me up one day to say he had written a book and wanted me to do the cover for it. Moreover, knowing that I liked monsters so much, he had created a spectacular one and named it after me in the book. That is, he had spelled my name backwards: Anewor.

'Oh, thank you. What fun!' said I, picturing a glorious, bejewelled, golden dragon. I could hardly wait.

When the manuscript arrived, I gleefully tore into it and found 'a gelatinous creature, dripping with stinking, oceanic slime. Drooling at its several mouths, it was equipped with grasping tentacles and could rip people's flesh into shreds.'

There was my namesake – spectacular, as promised.

THE DUNWICH HORROR
H.P. LOVECRAFT

I find H.P. Lovecraft's monsters so imaginative, and I had the most wonderful time putting together all the different textures and colours to depict this one. The head at the end of his tail may well be where I got my idea for the painting *The Mermaid's Tale* (see pp.32–33).

Right:
THE GARDEN OF STONE
VICTORIA STRAUSS

*T*here is always drama when a vibrant colour is played off a grey or monochrome background. This girl, in her vivid rose-coloured dress, along with the bright yellow rose, worked perfectly against the snowy landscape of stone leaves and flowers.

THE LAST STEWARD OF GONDOR
TOLKIEN CALENDAR

A blank canvas on the easel is invariably daunting and every painting presents its own distinctive challenge. What made this one particularly interesting for me was the need to group eight figures into a good composition. In other illustrations I would usually have a strong central figure and possibly one or two others. In this scene Aragon is receiving the sceptre of the city. I placed the tower directly behind him in order to emphasize his importance.

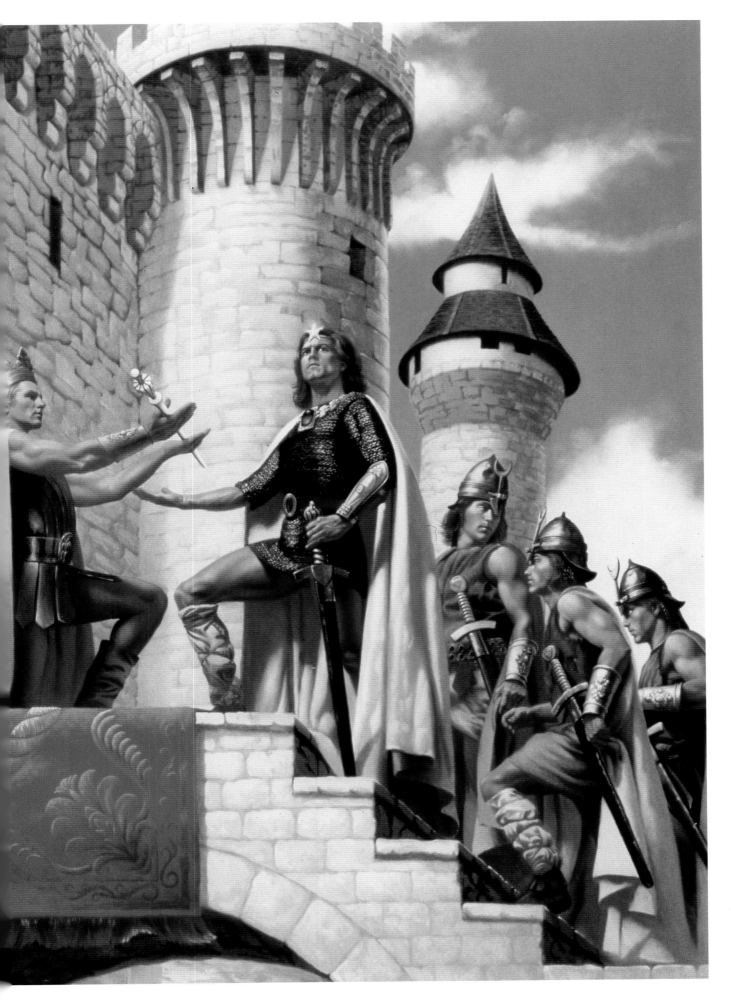

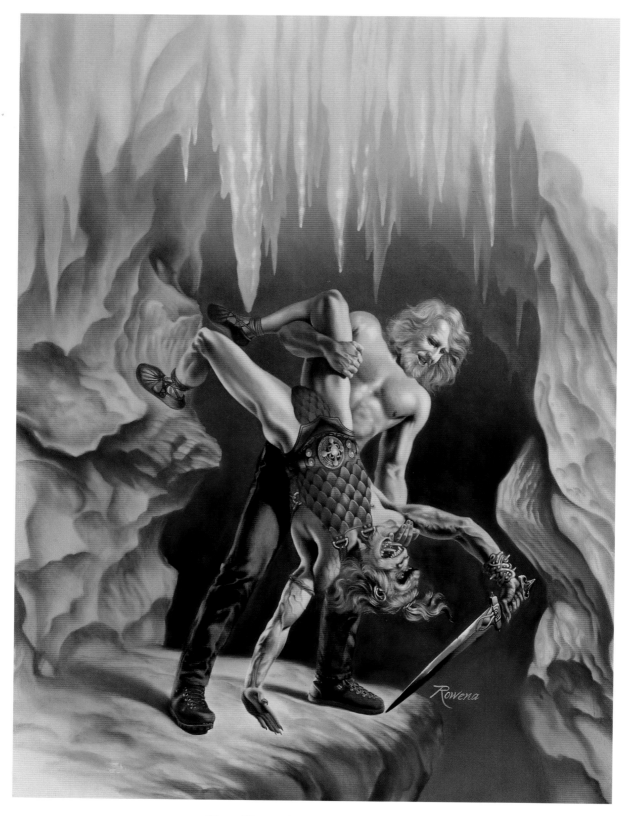

THE HAMMER AND THE HORN
MICHAEL JAN FRIEDMAN

I thought that the most evocative scene in this novel was of the hero hurling an ape monster over the cliff. So I contacted the biggest, brawniest, tallest model I knew, certain that he was exactly what I needed. I felt a flicker of worry when I saw him walking stiffly into the photography studio. Sure enough, he announced that he had badly injured his back and shouldn't do any heavy lifting! We collected boxes, chairs, in fact anything we could lay our hands on to prop him and the 'ape monster' up. It was a trial to get anything approaching an action pose from him. That problem is obvious to me whenever I look at this painting now.

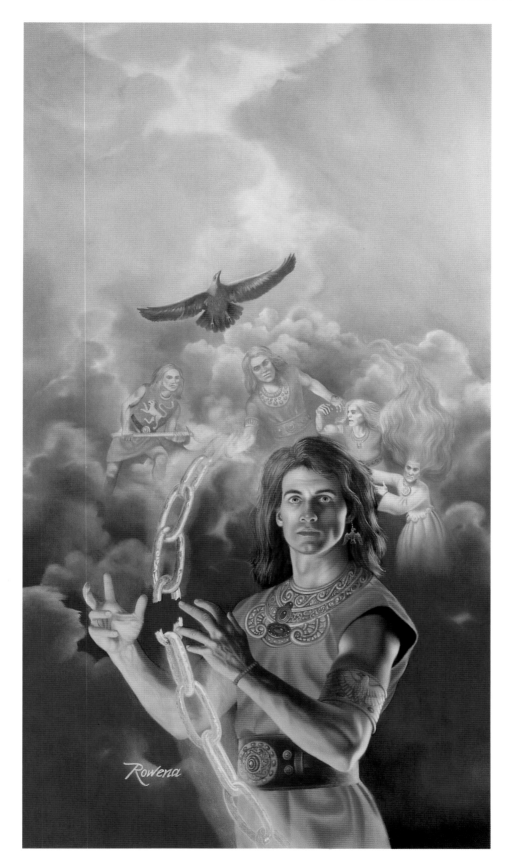

FLIGHT OF THE RAVEN
JENNIFER ROBERSON

*T*his painting was supposed to have the same feeling as the one of the girl holding a candle on the cover of *Ghosts I Have Been* (see page 7). I don't know which was more difficult: trying to get the chain to glow like the flame on a candle, or trying to get the same feeling in the figure of the Indian that I got in the young girl.

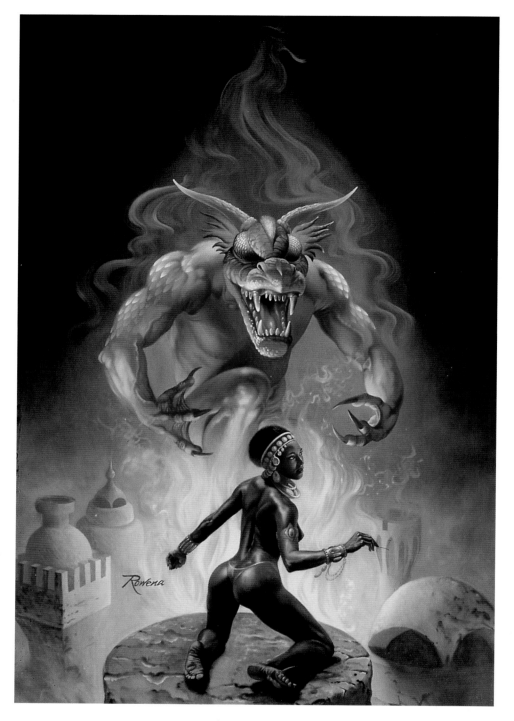

GOLEM 100
ALFRED BESTER

I used one of my favourite models as a reference for the anthropomorphic part of the Golem. When we had finished photographing and he was just about to leave, the female model arrived. She was very beautiful and dramatic-looking, with gorgeous dark skin. The male model had seen the preliminary sketch for this painting, and knew she wasn't going to be wearing much in the way of clothes! I could barely get him out of the door; he managed to find one excuse after another to hang around until he actually caught a glimpse of her in the nude.

Right:
THE POWERS THAT BE
ANNE MCCAFFREY AND ELIZABETH SCARBOROUGH

*T*his is another variation of the powerful authoritative woman in an all-purpose front-zippered jump-suit, one that my photographer had in his costume wardrobe.

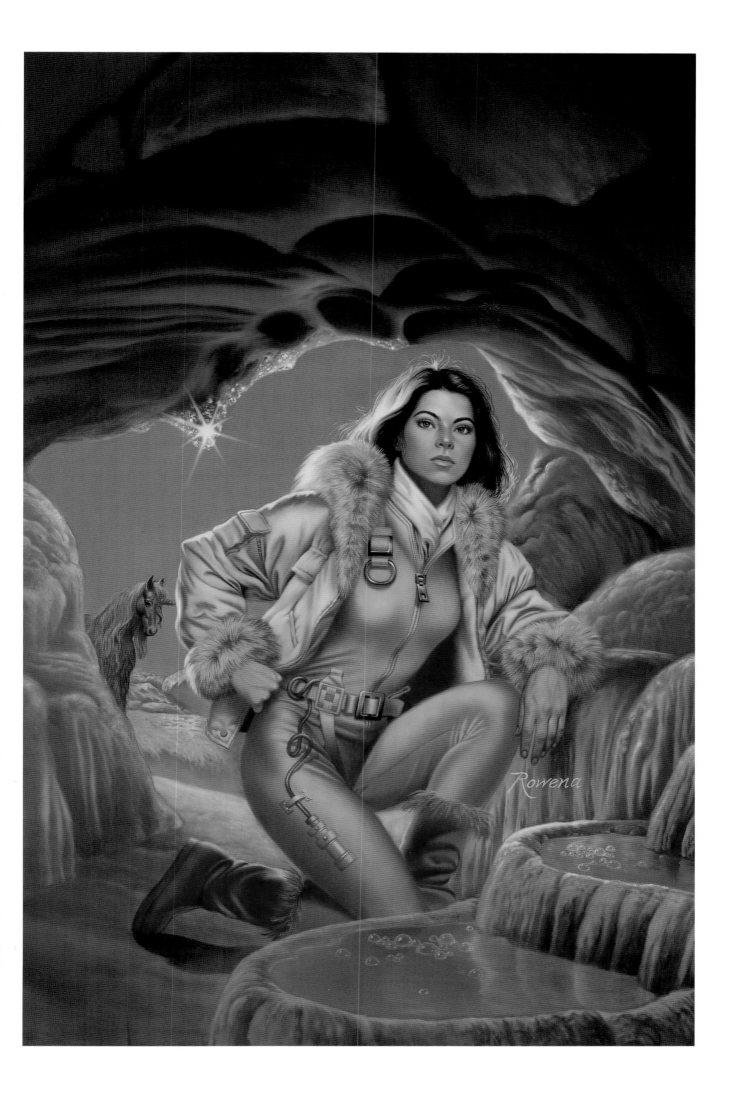

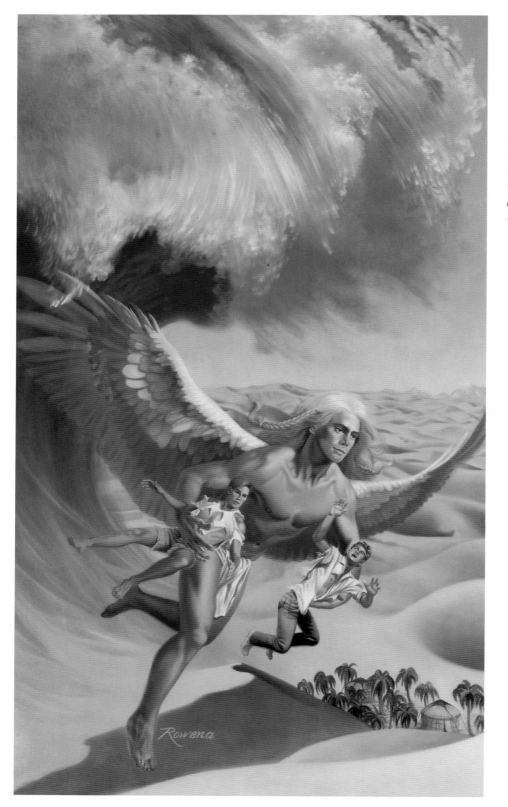

MANY WATERS
MADELEINE L'ENGLE

It is always an interesting exercise to set people up to look as though they are flying through space. What appealed to me here was the surrealism of the three characters who were escaping from a tidal wave in the middle of the desert.

Right:
HARM'S WAY
COLIN GREENLAND

When I got this commission the model Fabio had just gone to California. His departure created a vacuum and gave rise to any number of Fabio look-alikes. This was one of the more popular ones. Being an artist makes me acutely aware of the visual, and he was certainly something to see. A female artist once said, 'You paint the men that you'd like to have and the women you'd like to be.' That is eminently true for me. It's fun to imagine what it would be like to walk out onto my balcony and be swept up in the feathery, silken embrace of a sexy male angel.

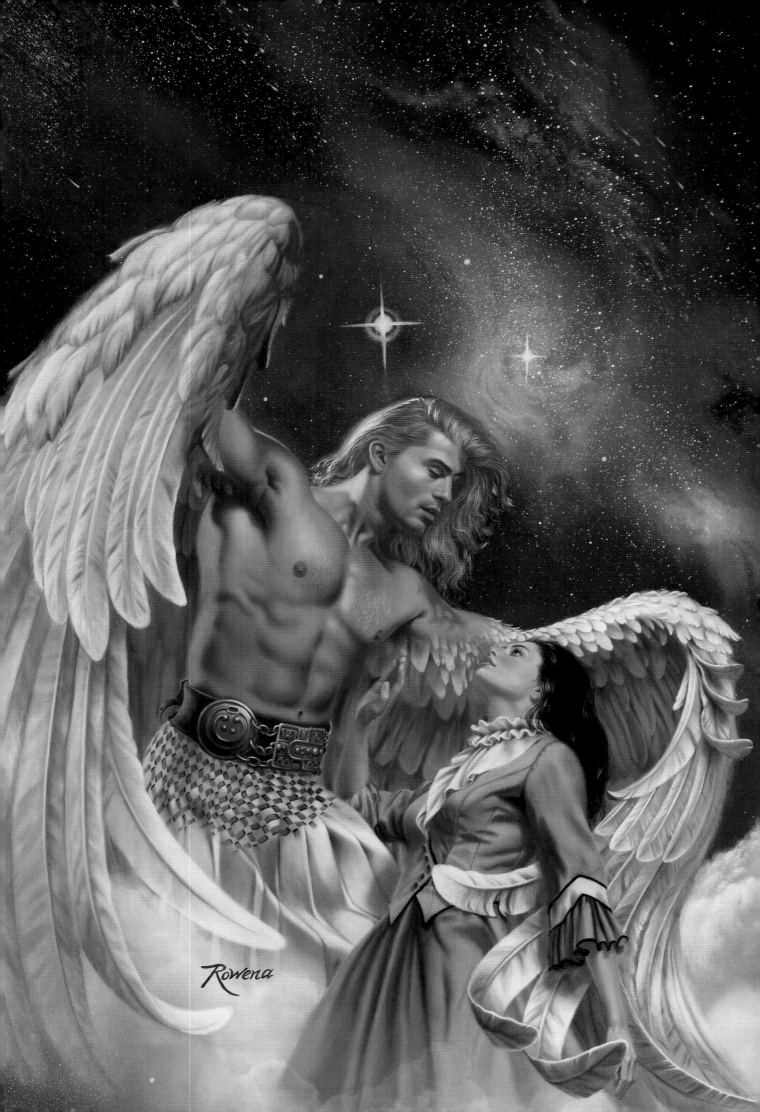

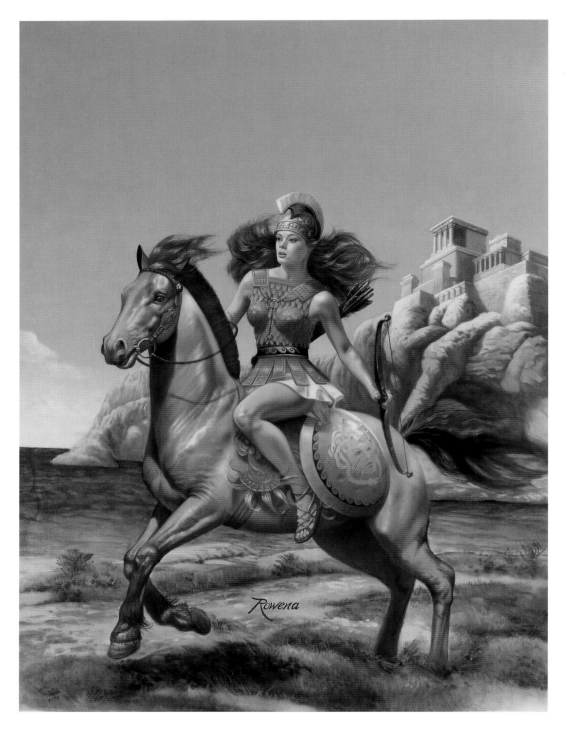

A SWORD IS FORGED
EVANGELINE WALTON

*I*t is difficult to find models who are as easy to work with as this one. She would get into whatever pose I wanted with such ease. I have painted her as vastly different characters, ranging from a lovely placid girl to an Amazon warrior.

Right:
THE SHAPE CHANGER
KEITH LAUMER

I love the humour in this scene. Obviously the lady is a trap for the hero. I found it an entertaining twist on the classic theme of a hero coming to rescue a maiden in distress.

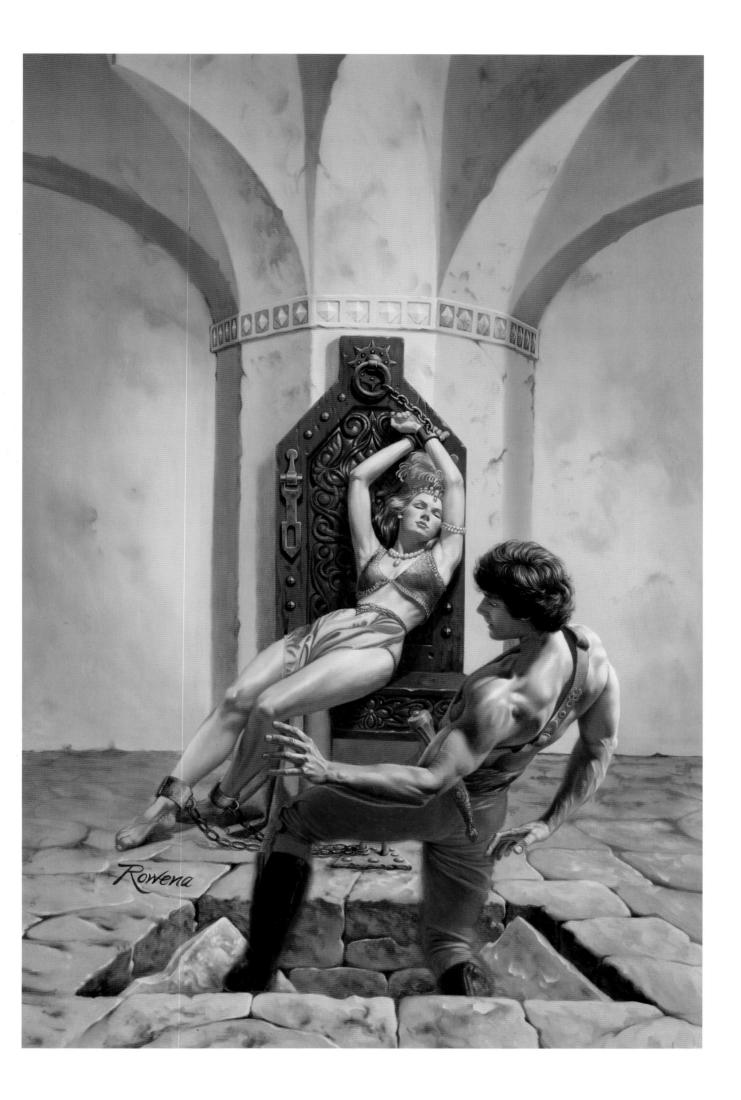

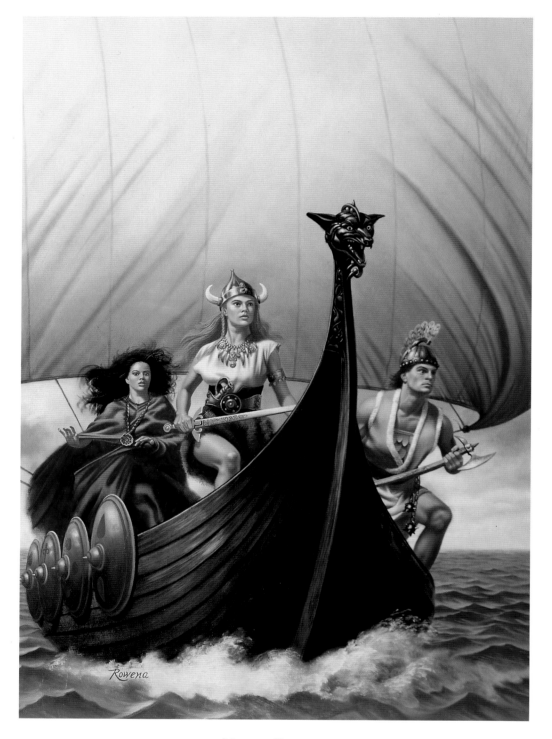

NIGHT REAVER
MICHAEL D. WEAVER

*W*hen I first started my career in illustration there was a big demand for sexy-looking women on book covers. That began to change during the 1980s. Numerous books were published with dominant females, protagonists who looked as though they were running the show.

Right:
DARKSPELL
KATHARINE KERR

*T*his is a dark and wicked magician conjuring up a magical spell. I had as much pleasure painting minor details here as the magician per se. The dragon candle-holder, for example, provided an opportunity to add my own personal touches to an otherwise prescribed image.

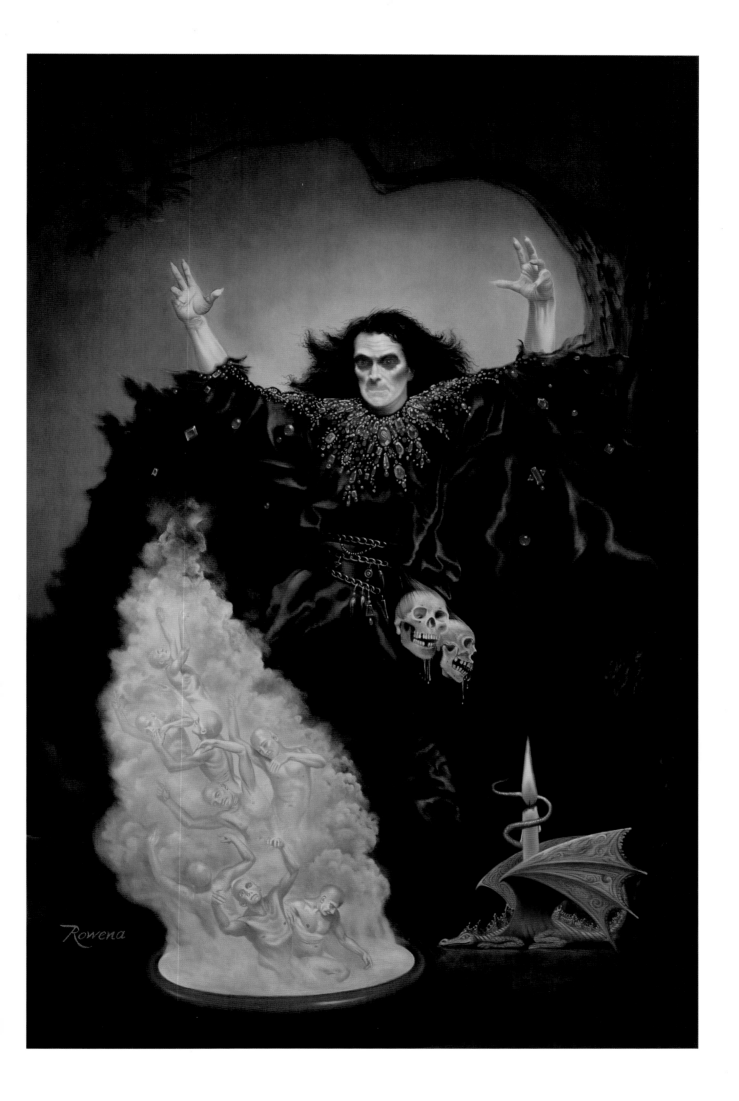

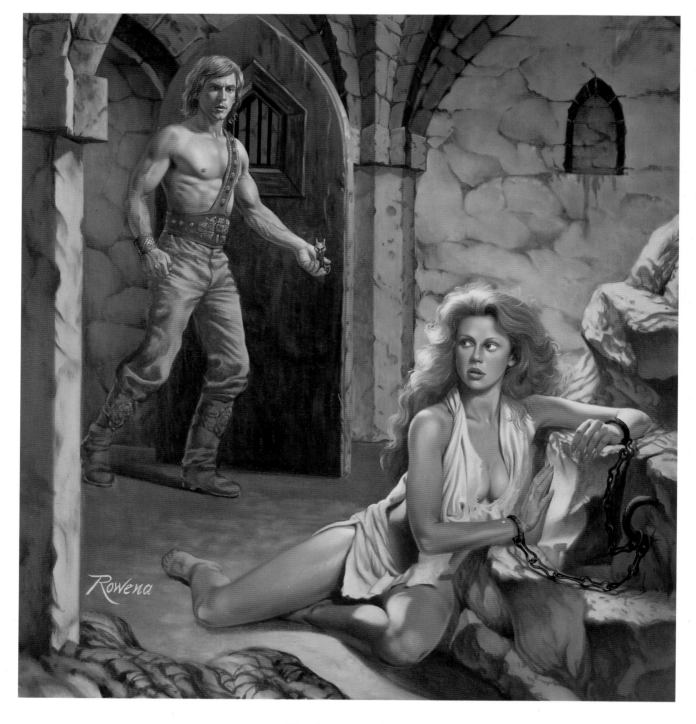

NO EARTHLY SHORE
FRANCINE MEZO

To begin with, I was told to make this lady beautiful, voluptuous and scantily clad. When I brought the painting in, however, the marketing department decided that she was *too* scantily clad. So I had to take her home and cover her up a bit. I painted two additional strings across her torso and that seemed to do the trick.

Right:
NO CLOCK IN THE FOREST
PAUL J. WILLIS

I found the naughty girl looked even naughtier in contrast with the sweet one, an intriguing image. However, the background was very much dictated. I was instructed to add an evil groundhog to it, which was remarkably difficult for me. I find them so adorable that the idea of an evil groundhog is an oxymoron in my opinion. Nevertheless, here he is.

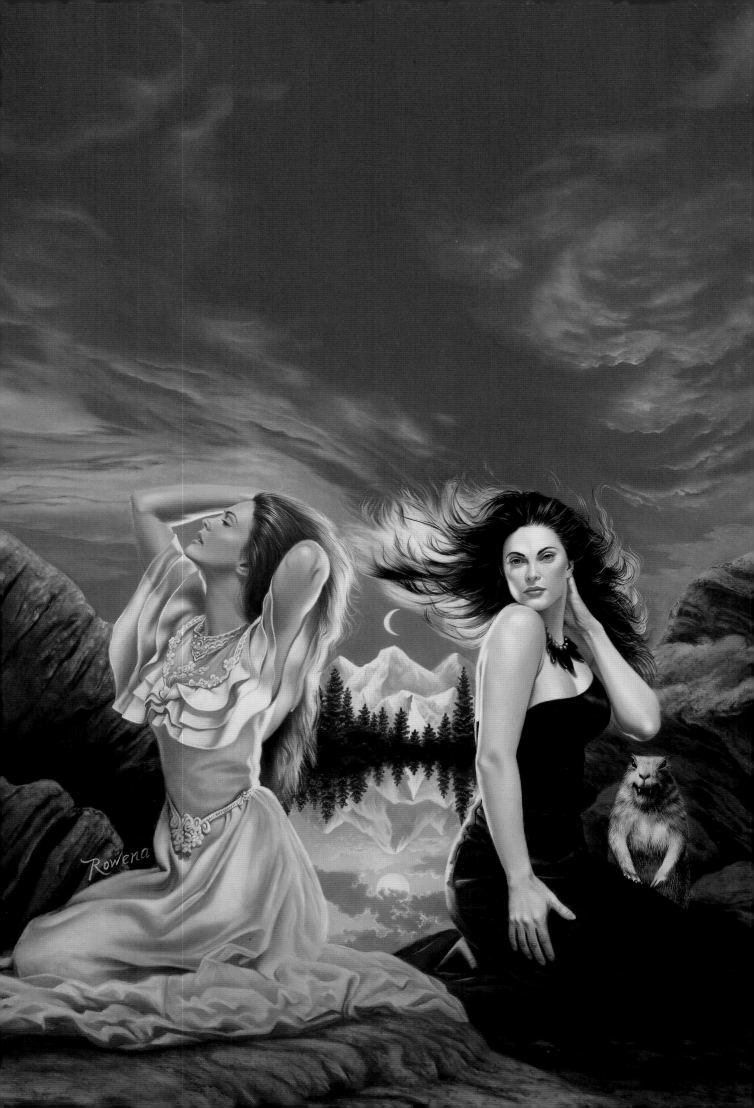

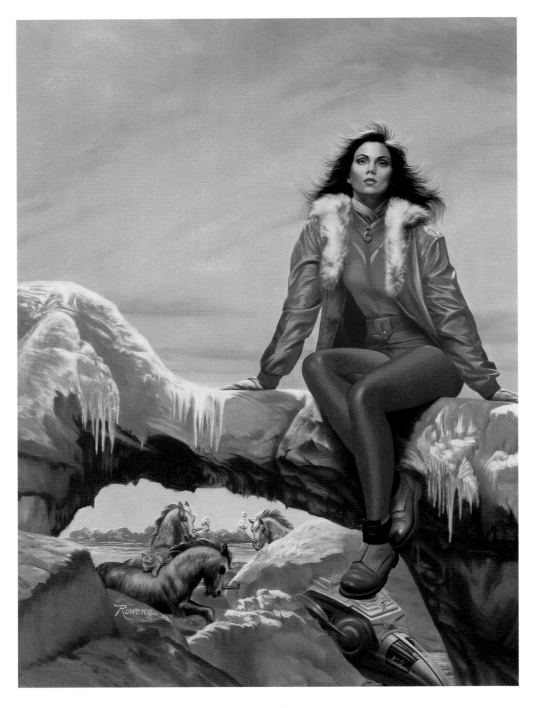

POWER PLAY
ANNE McCAFFREY AND ELIZABETH SCARBOROUGH

*T*he unicorns in the background are supposed to be chipping the spaceship out of the ice. I really laboured at getting the chips to look ice-like. Satisfied in the belief that I had done a rather credible job, I was none too pleased when a friend of mine offered the unsolicited opinion that the unicorns looked like smoking horses.

Right:
POWER LINES
ANNE McCAFFREY AND ELIZABETH SCARBOROUGH

*F*or this painting the publishers requested a combination of elements that proved challenging to put together. They wanted a weed-choked helicopter with cougars lying on it and a cave in the background. Those were pretty disparate images and I had to struggle to make them work as a whole without the picture looking odd. I had also given the vines subtle mossy hues, and was surprised to see that they had been changed (by computer) to an acid green.

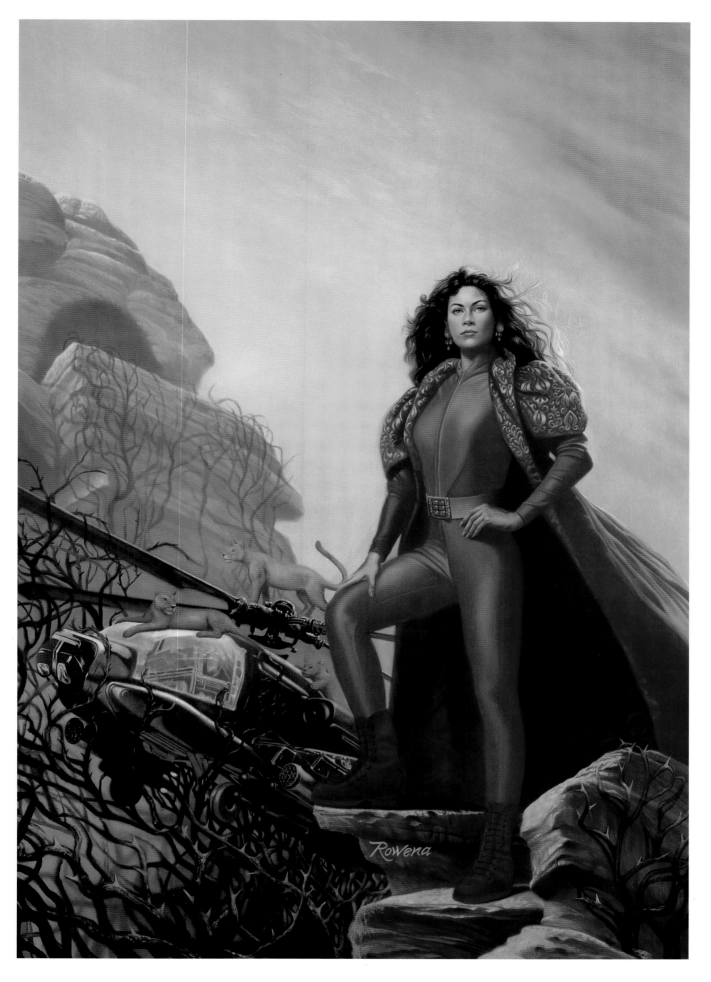

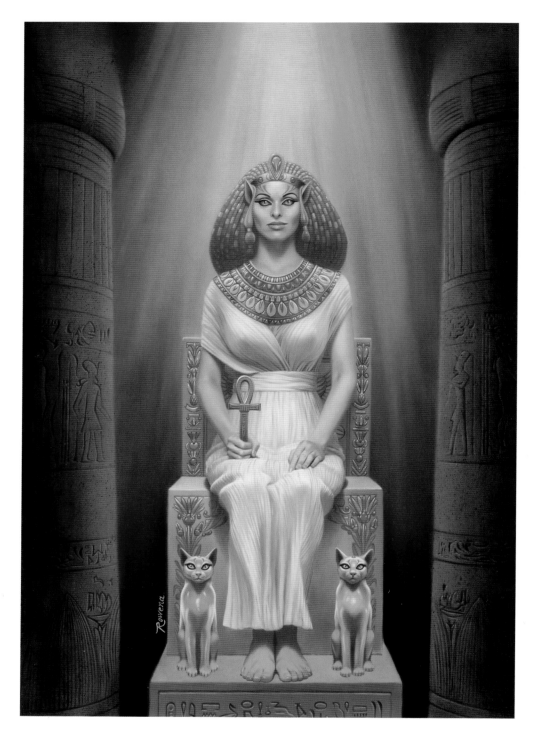

THE HIDDEN LAND
SARAH ISIDORE

*T*he publisher wanted me to use a model with exotic, feline features and a very voluptuous figure.

Right:
QUEENSBLADE
SUSAN SHWARTZ

I like the timeless look of the old man. What he is wearing could be seen today in a monastery, or, for that matter, on the streets of New York.

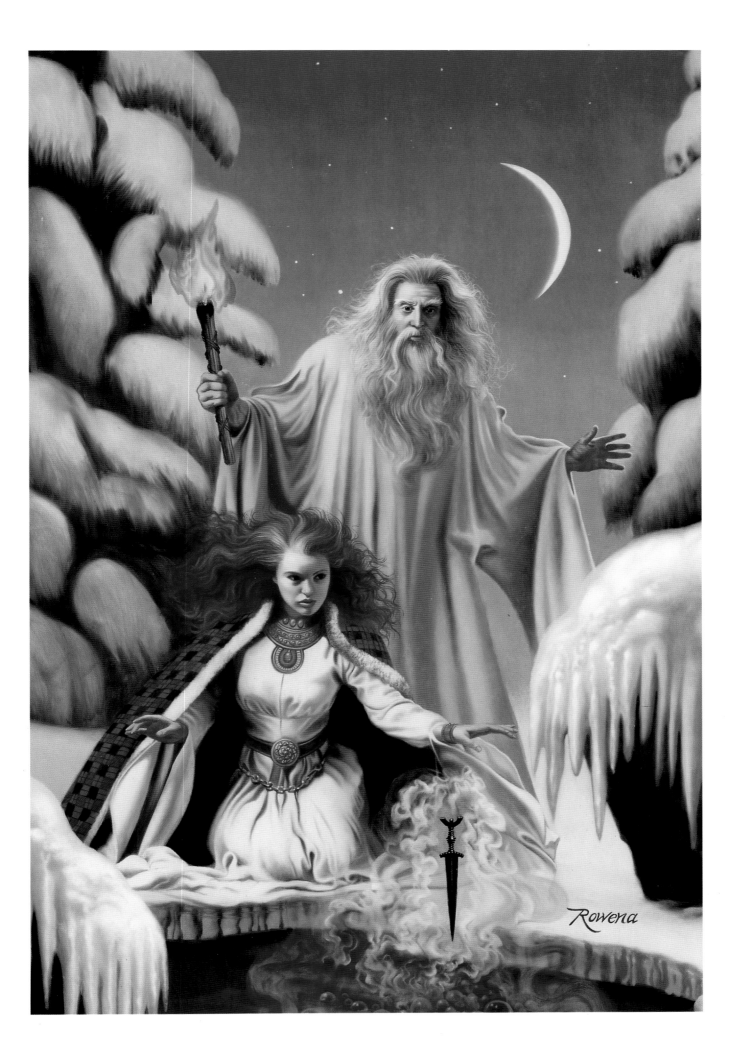

Rowena

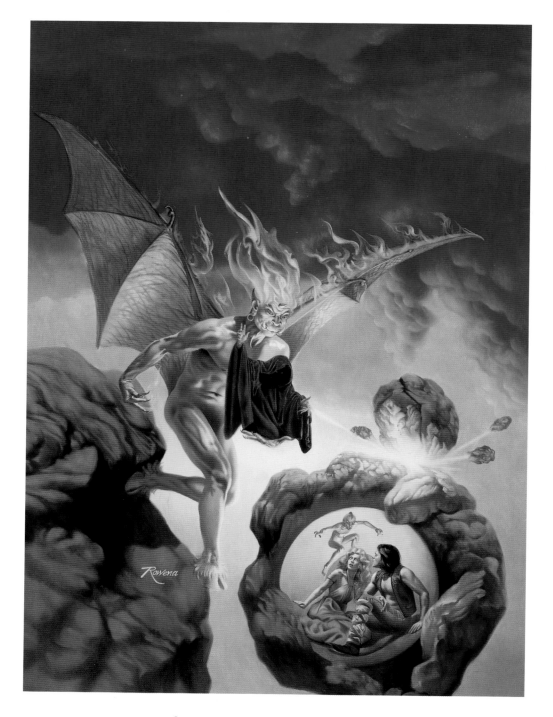

SECRET OF THE SIXTH MAGIC
LYNDON HARDY

*M*y model posed for all four male figures. I find it amusing to have one person being both the hero and the villain. Interestingly enough, the models seem to have more fun posing for the savage demons than they do for the honourable heroes. I guess there is more spice, more of the outrageous in the character of a demon.

Right:
SHADOWS OUT OF HELL
ANDREW J. OFFUTT

*T*his novel, about a malevolent god and his priestess, had plenty of colourful action scenes. Here, the priestess has made a snake materialize out of nothing and pursue the man. We had to photograph the male model one limb at a time. We propped him up on telephone books and wrapped a tube around his body to serve as the snake. The photographs from this kind of session are always highly amusing.

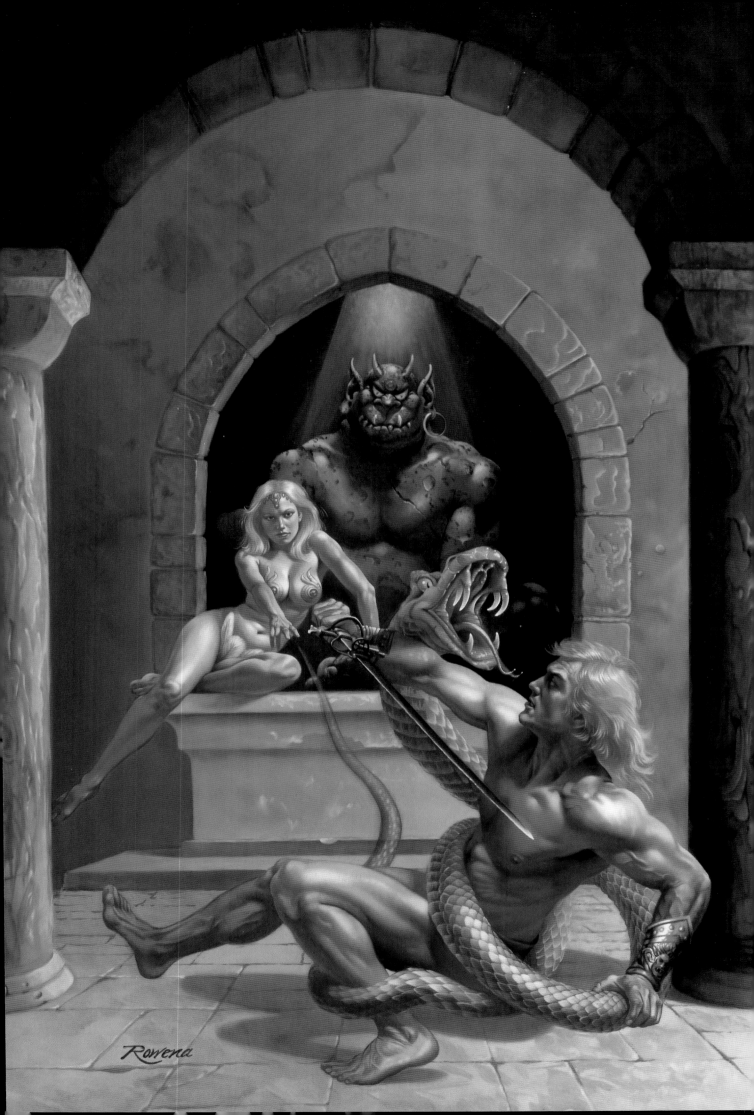

Rowena

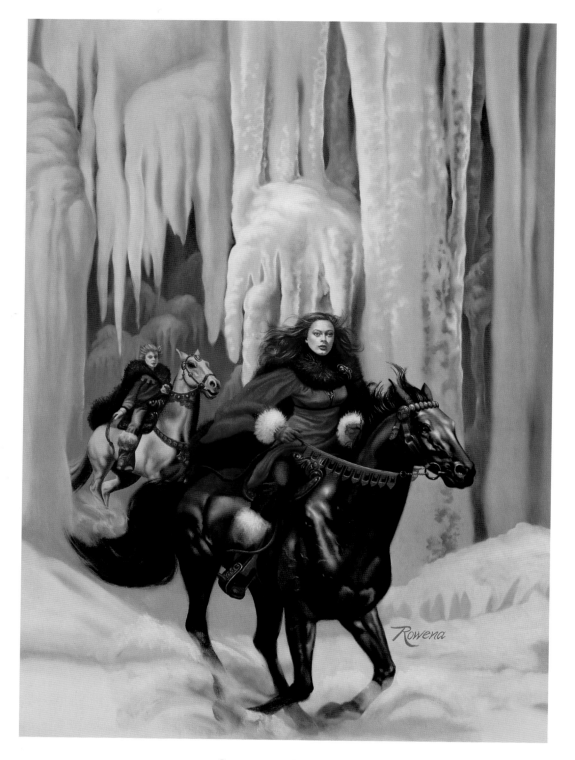

SWORD OF WINTER
MARTA RANDALL

*M*y photographer has a plywood mock-up of a horse that he calls 'Splinters'. This ersatz horse has carried some of the most gorgeous men and women in New York on his back.

Right:
SHRINE OF LIGHT
SARAH ISIDORE

*T*his scene was entirely dictated to me, right down to the details of the chair and the sceptres.

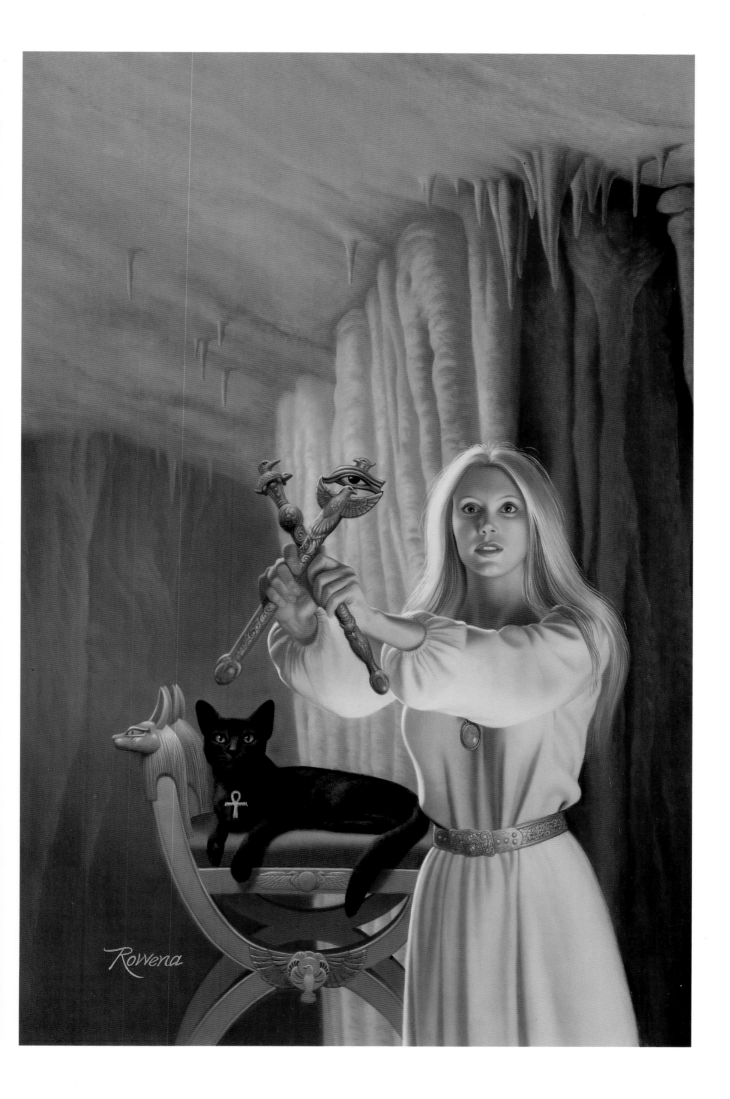

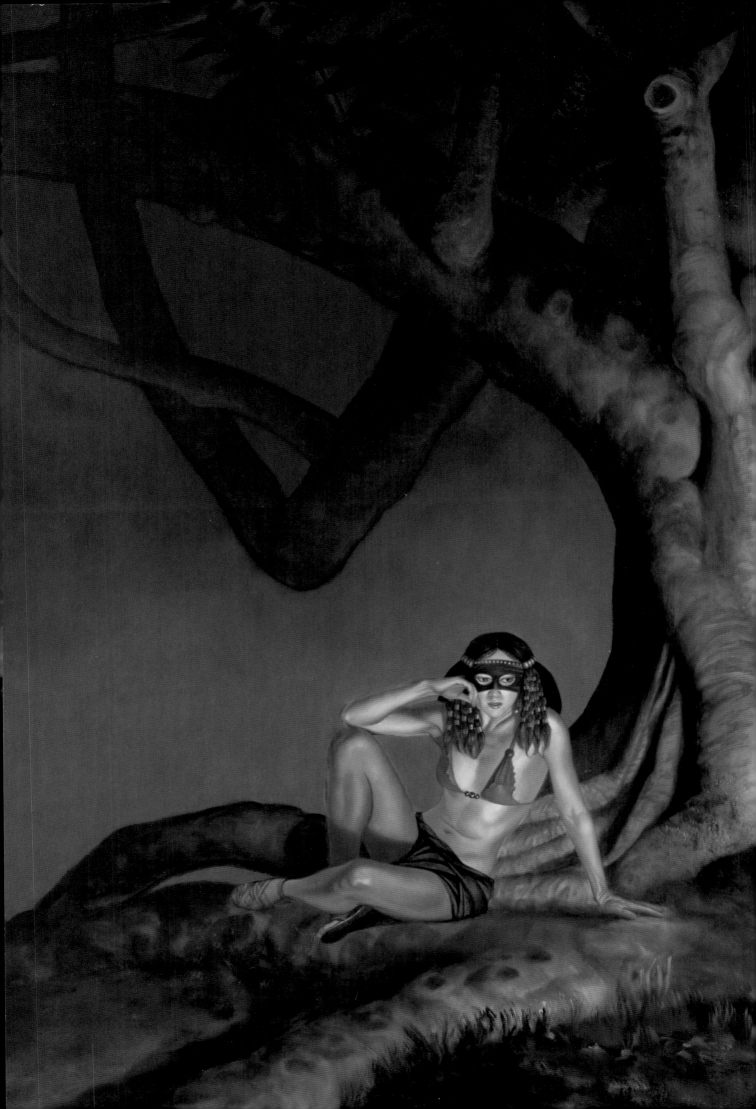

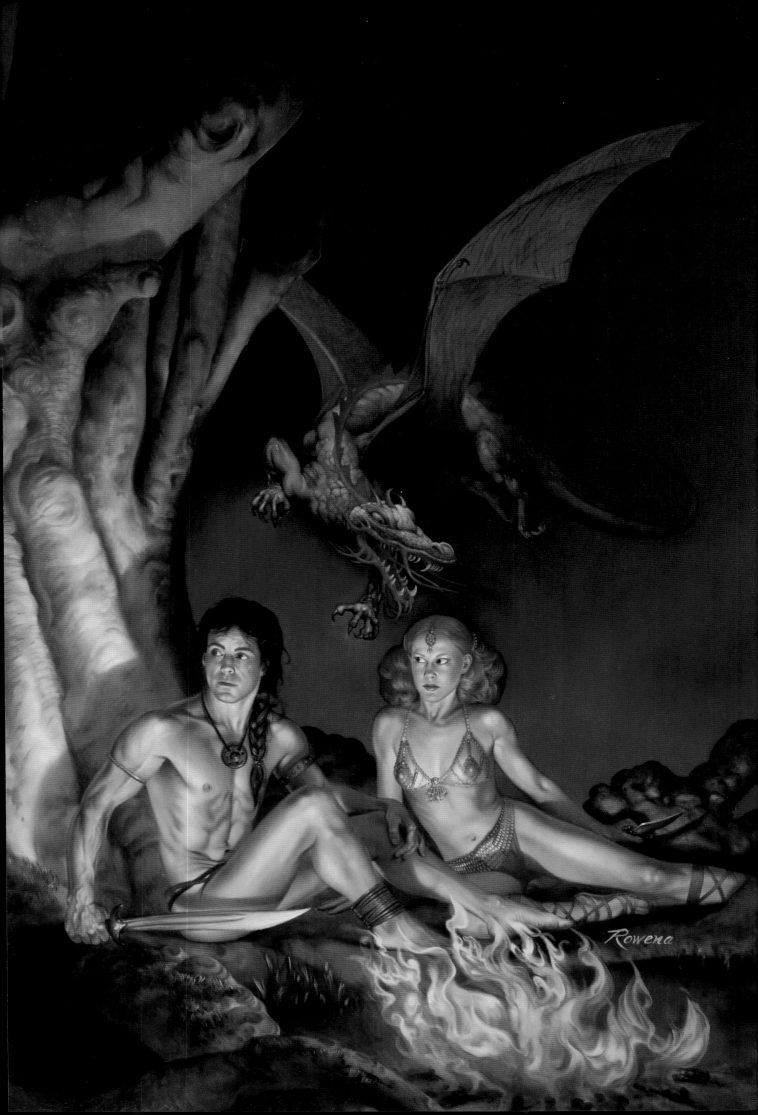

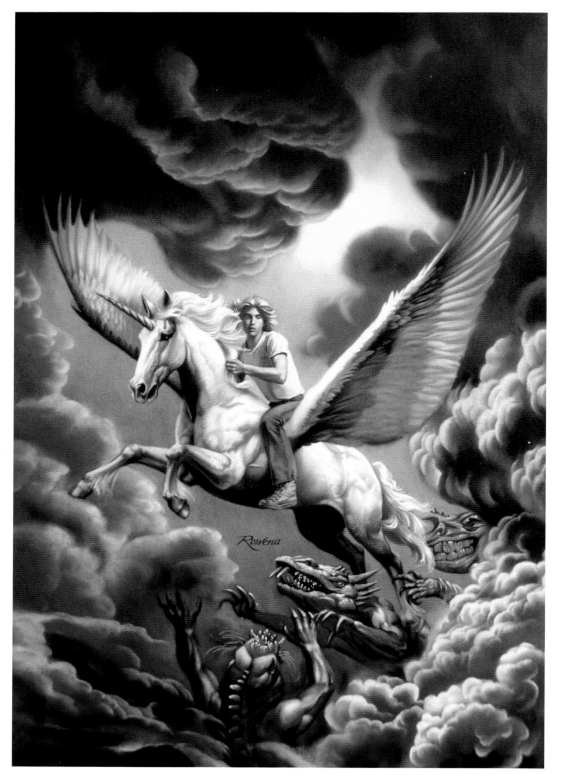

A SWIFTLY TILTING PLANET
MADELEINE L'ENGLE

*T*his was for a Madeleine L'Engle novel. It was one of my very earliest book cover commissions and I felt honoured to be doing it for one of her wonderful stories.

Preceding pages:
TALES OF NEVÈRŸON
SAMUEL R. DELANY

*M*y first idea, a large dragon materializing out of the dark, was rejected by the art director.

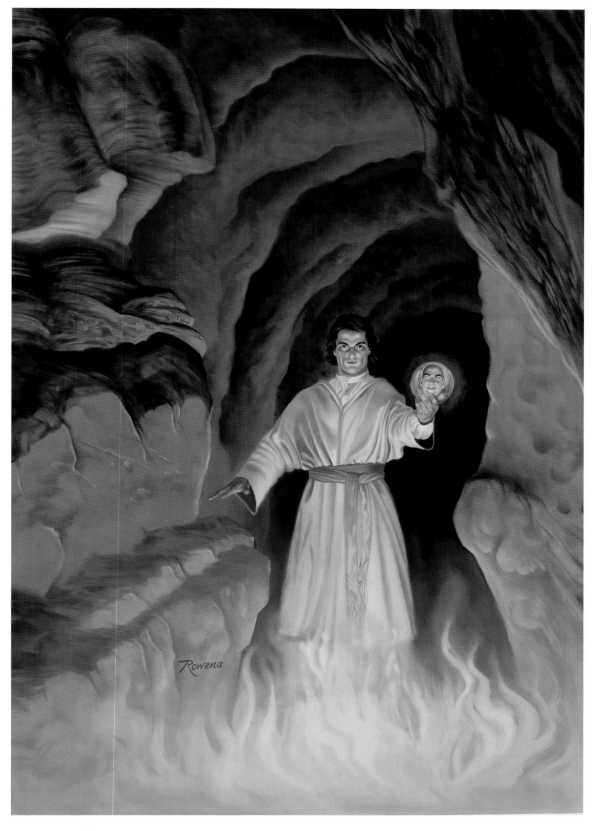

FOR LOVE OF EVIL
PIERS ANTHONY

This theme really appealed to me. The idea was to show two opposing sides of human nature. The monk is holding a globe that contains his alter ego or wicked side. A friend who could get the most diabolical expression on his face posed for me, and we had great fun shooting it.

THE SWANBOAT OF GALADRIEL
TOLKIEN CALENDAR

*T*his painting, with its fairytale atmosphere, captures the images I fantasized about as a child. To escape from the agonizing boredom of sitting through the first 12 years of school, I would daydream about enchanted kingdoms with beautiful princesses and handsome princes.

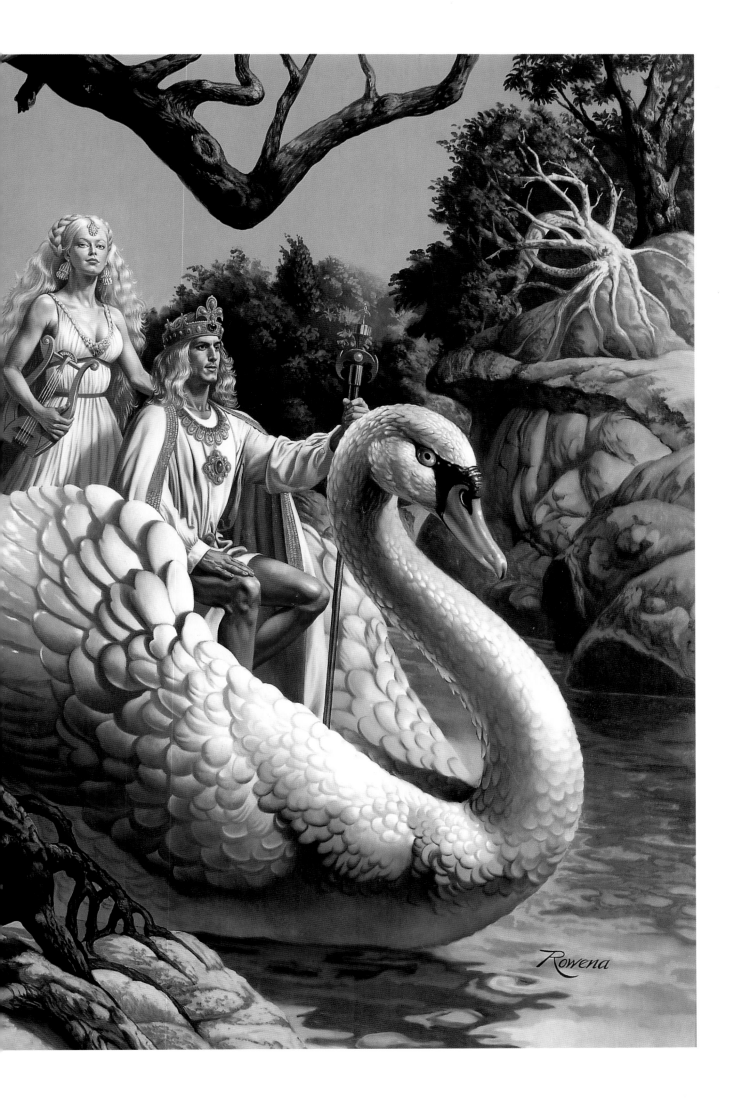

Rowena

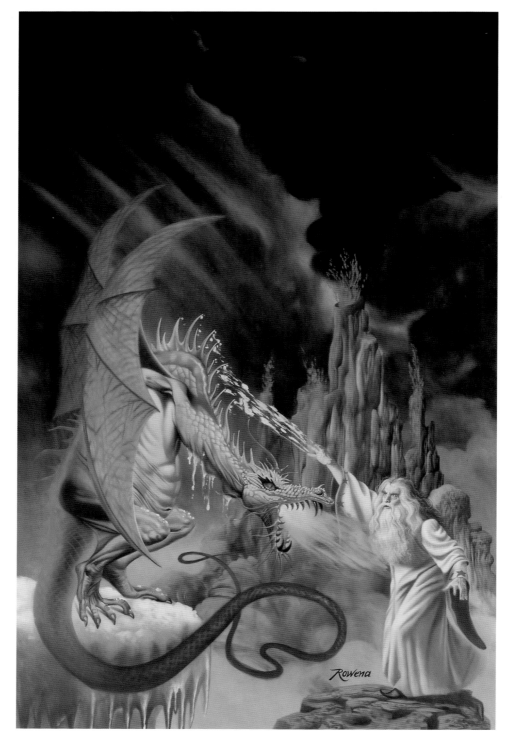

WIZARD AT LARGE
TERRY BROOKS

I largely based this dragon on those typical in Chinese art. Even so, I had a human model pose in order to develop believable anatomy and musculature.

Right:
ETERNAL WARRIORS: THE WAR IN HEAVEN BOOK ONE
THEODORE BEALE

*T*heodore Beale, the author, had complete control over choosing the artist to do his book cover and determining how the painting was to look. This was a real pleasure for me. We discussed the themes and the characters in the book, and came up with a striking image for the cover that pleased us both.

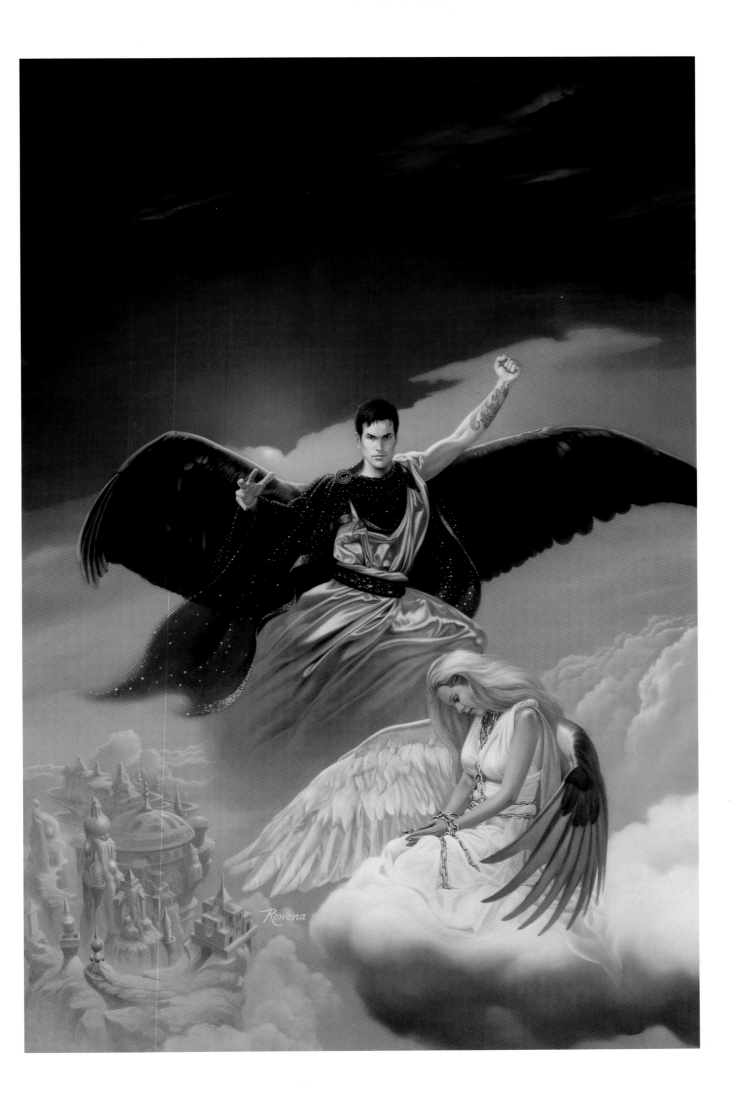

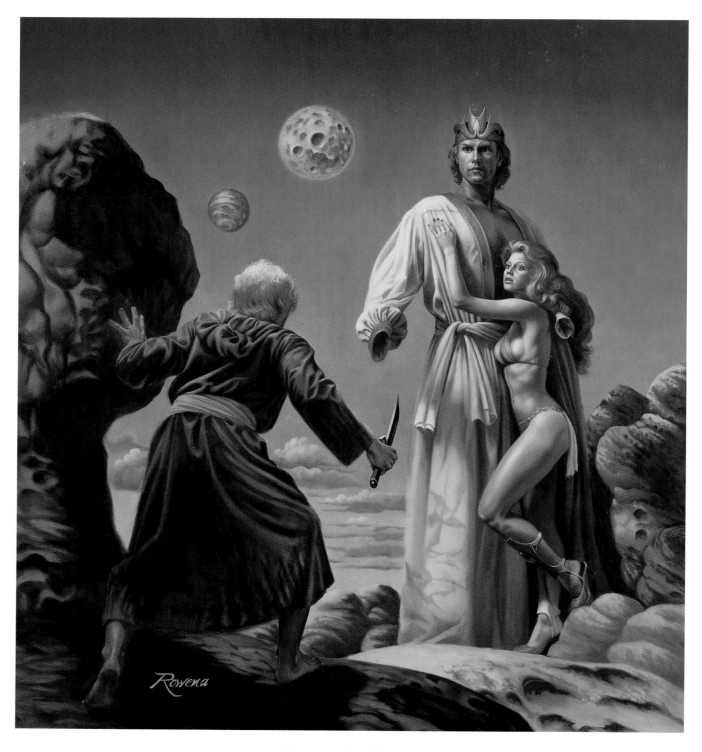

UNLESS SHE BURN
FRANCINE MEZO

I was a little daunted by the prospect of making a man without hands look appealing. Once I painted the empty sleeves, the problem proved to be non-existent. The focus of attention, after all, was the girl.

Right:
TO THE HIGH REDOUBT
CHELSEA QUINN YARBRO

*W*hen I found this scene in the book, I knew it was the one I had to paint. It was especially dear to my heart because of all the times I had sat in front of campfires, day-dreaming.

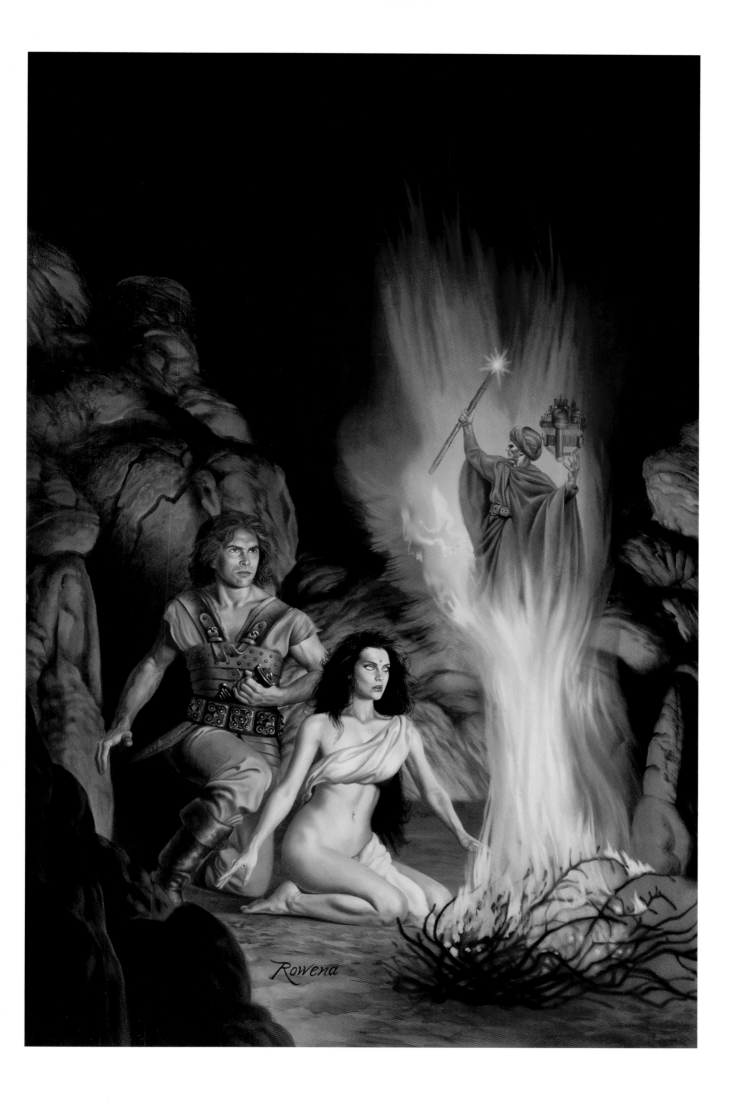

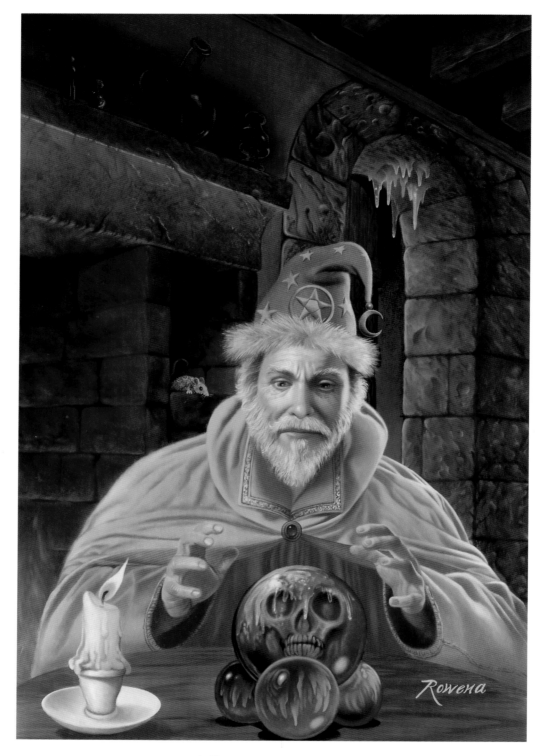

A FACE IN THE FROST
JOHN BELLAIRS

A fellow artist posed as the magician. His patched-together outfit was a blanket and a skiing hat.

Right:
THREE FROM THE LEGION
JACK WILLIAMSON

*I*t is so common for women to be carried off by monsters that it struck me as droll to show a man being carried off instead. The model I used here posed for almost every heroic male figure I painted in five years. We had an excellent rapport and I was truly sorry when he left modelling to follow a new career.

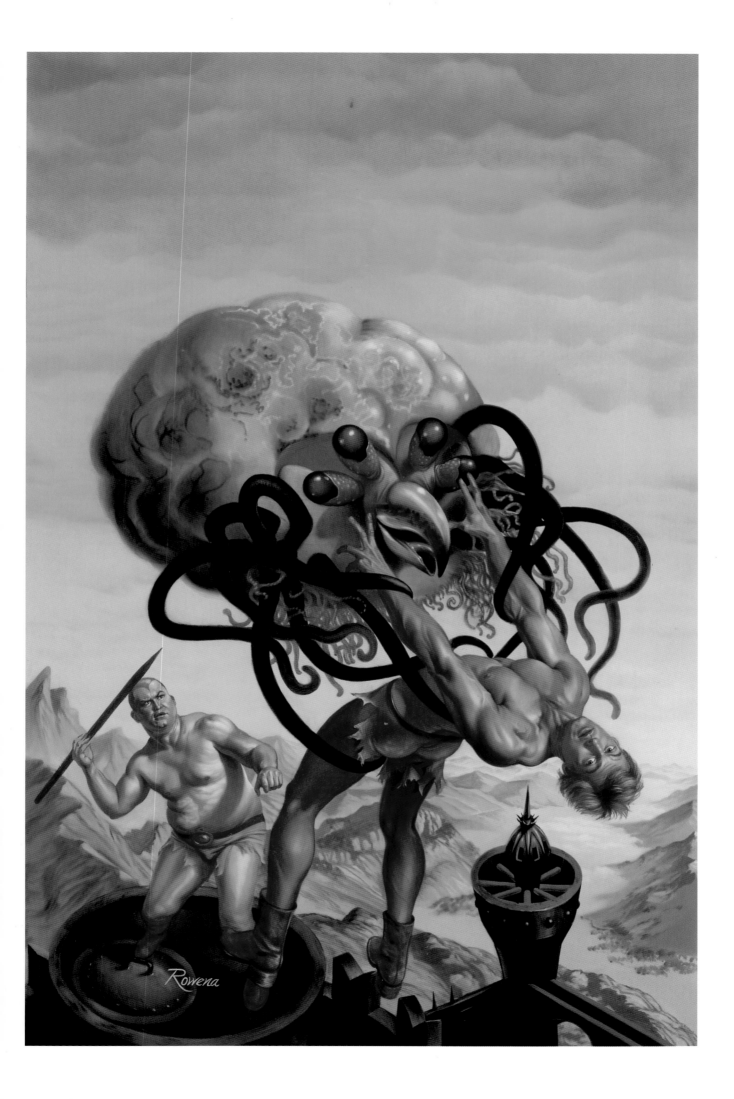

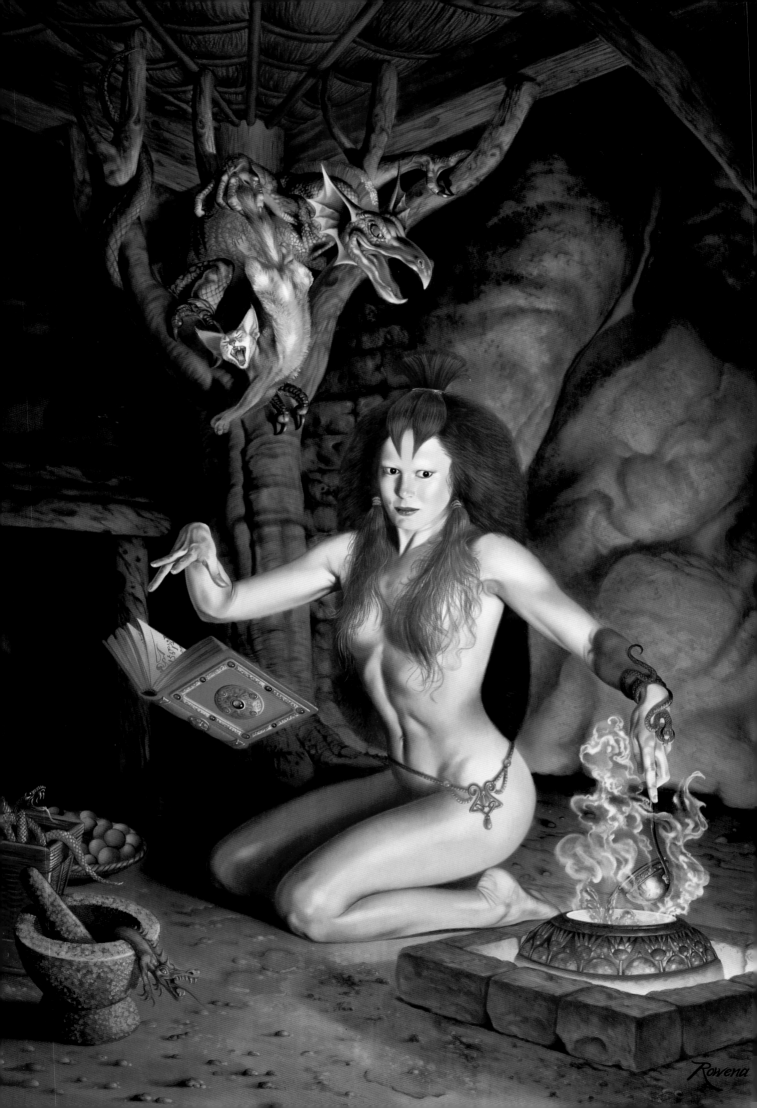
Rowena

MAGAZINES
AND GAMES

SORCERESS

This was for the catalogue of an art and book collection. The client requested only that it show a beautiful girl and a book. I chose to make the latter a cookbook and the former a sorceress cooking up a spell.

Occasionally I use myself as a model, and I did here. It reduces my expenses, but that is only a minor benefit. The real fun is to flatter myself shamelessly and make myself look exactly the way I want to. I have never failed to come off well when painting myself.

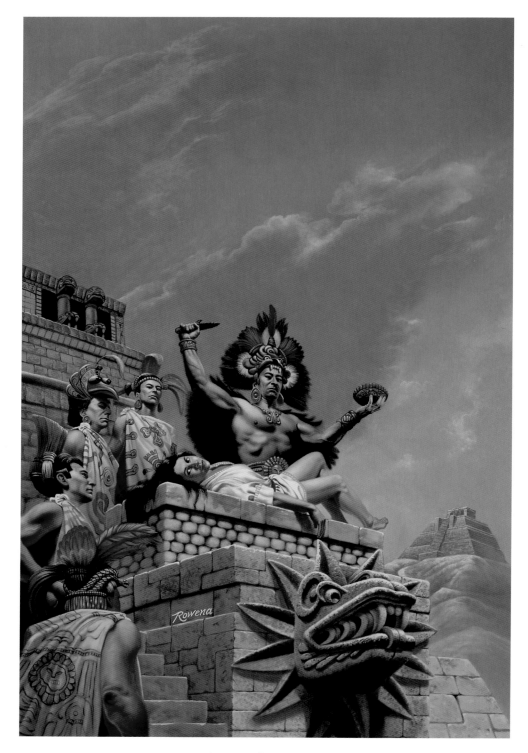

AZTEC SACRIFICE
STEVE JACKSON GAMES

*D*oris was the model for the girl being sacrificed by an Aztec priest. Unfortunately I was pressed for time, with a very tight deadline, and I unwittingly made her legs too short.

Right:
DRAGON'S NEST
HEAVY METAL COVER

I particularly like the opposing twists and curves of the girl's and dragon's bodies, which are entwined together. We photographed the girl lovingly caressing a metal lightshade, which was set up as a surrogate for the dragon's head. This girl had a wonderful sense of humour, and I would still be using her as a model if she hadn't married and moved away.

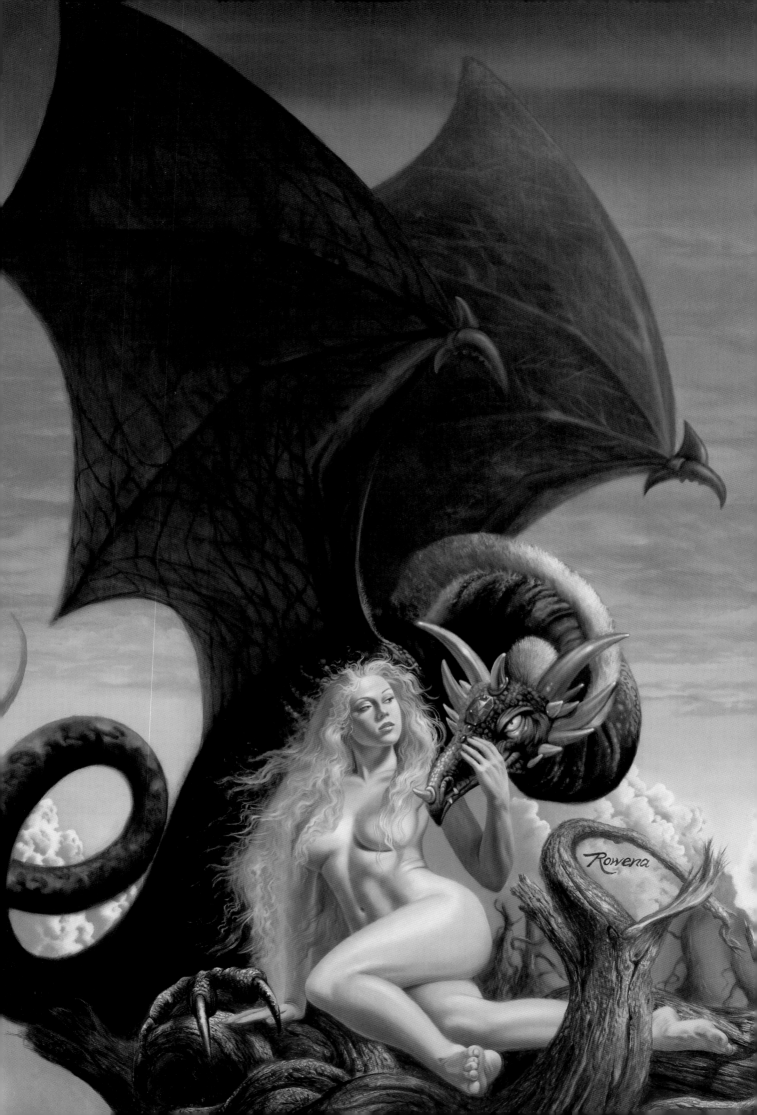

WINTER PLEASURES
NATIONAL LAMPOON COVER

'Can't she just patch it together from some photos out of *Playboy*? What the hell, isn't she an artist? Can't she just make it up?' These remarks crescendoed down the hallway as I waited in the art director's office. The editor wanted one of my realistic figures, but was unwilling to pay for a model.

Right:
FASCINATING FLAMES
SCHANES & SCHANES PORTFOLIO

The idea for this painting came from an evening I spent with three of my girlfriends – all of us comparing notes on the inappropriate men we were currently smitten with. Each of us thought that the others' infatuations were irrational and uproariously funny. The image this evoked for me was of a surreal, exotic, beautiful man – made of fire – and a girl, drawn like a moth to the flames.

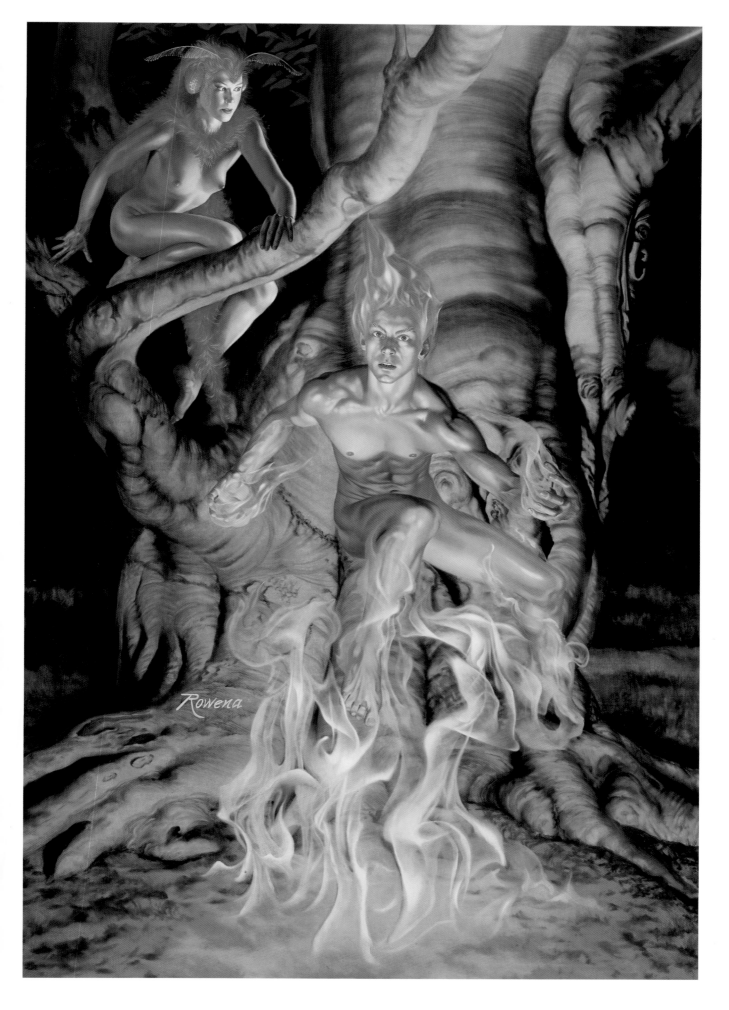

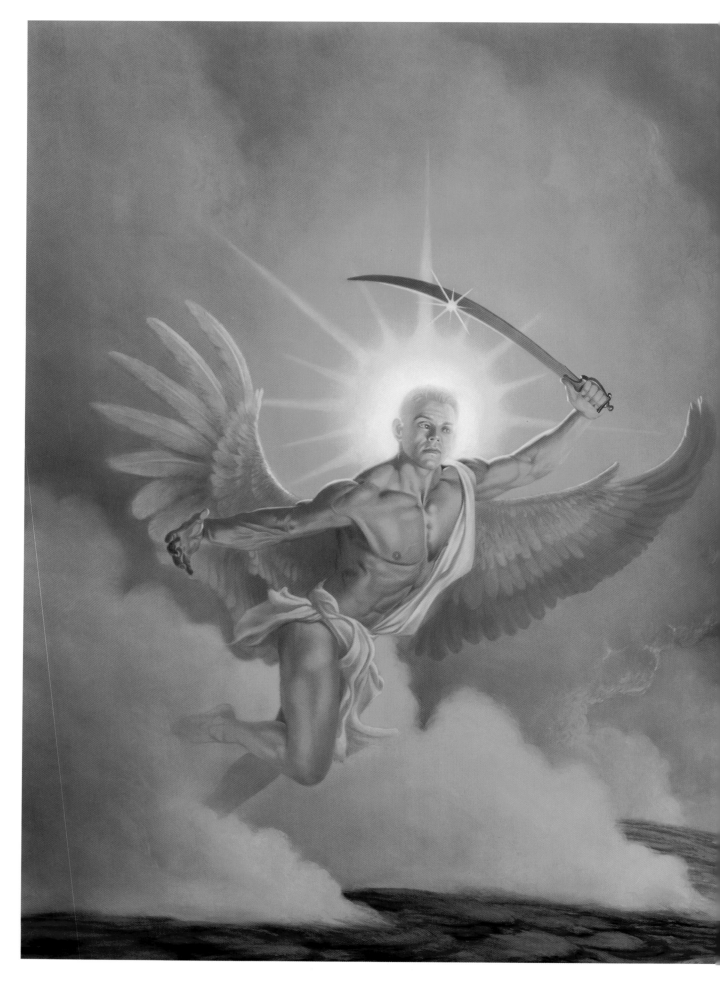

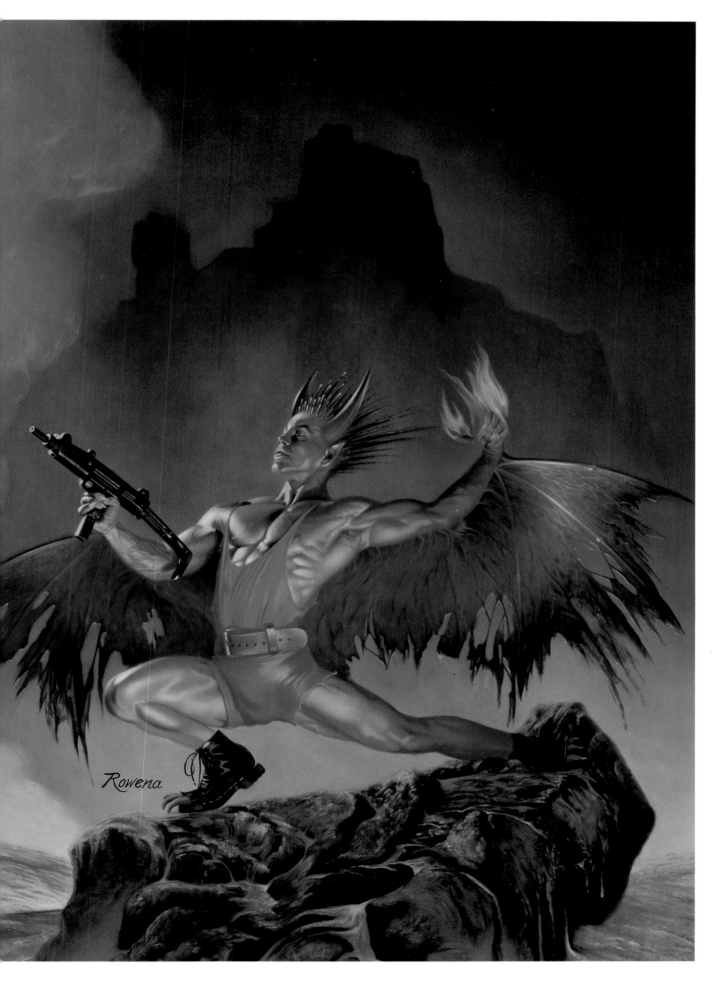

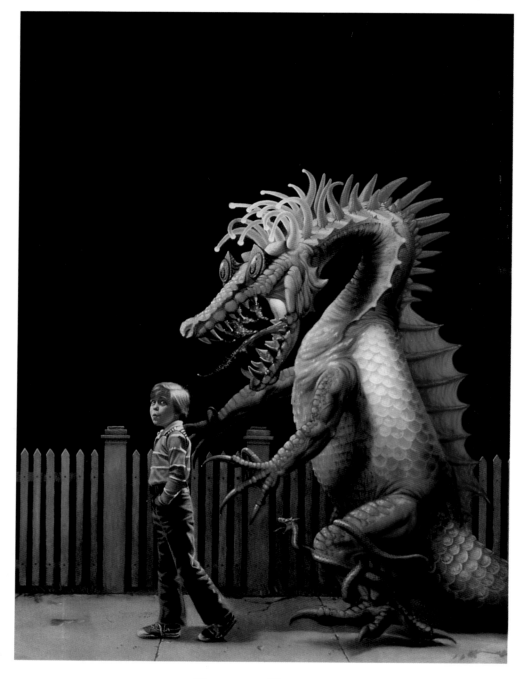

TWILIGHT TERRORS
NATIONAL LAMPOON COVER

I just loved the theme of this piece: what you can imagine alone in the dark. When the painting was in a museum exhibition, I noticed that people of all ages were drawn to it.

Right:
GARGOYLE
HEAVY METAL COVER

I am grateful to Maya Vallejo for miraculously digitally restoring this painting so that it could appear in this book – it had been completely folded in half by a shipping company.

Preceding pages:
IN NOMINE
STEVE JACKSON GAMES

*T*here wasn't much time for this. Neither was there money for a model in the budget – I ended up going to a gym where I found the perfect body-builder.

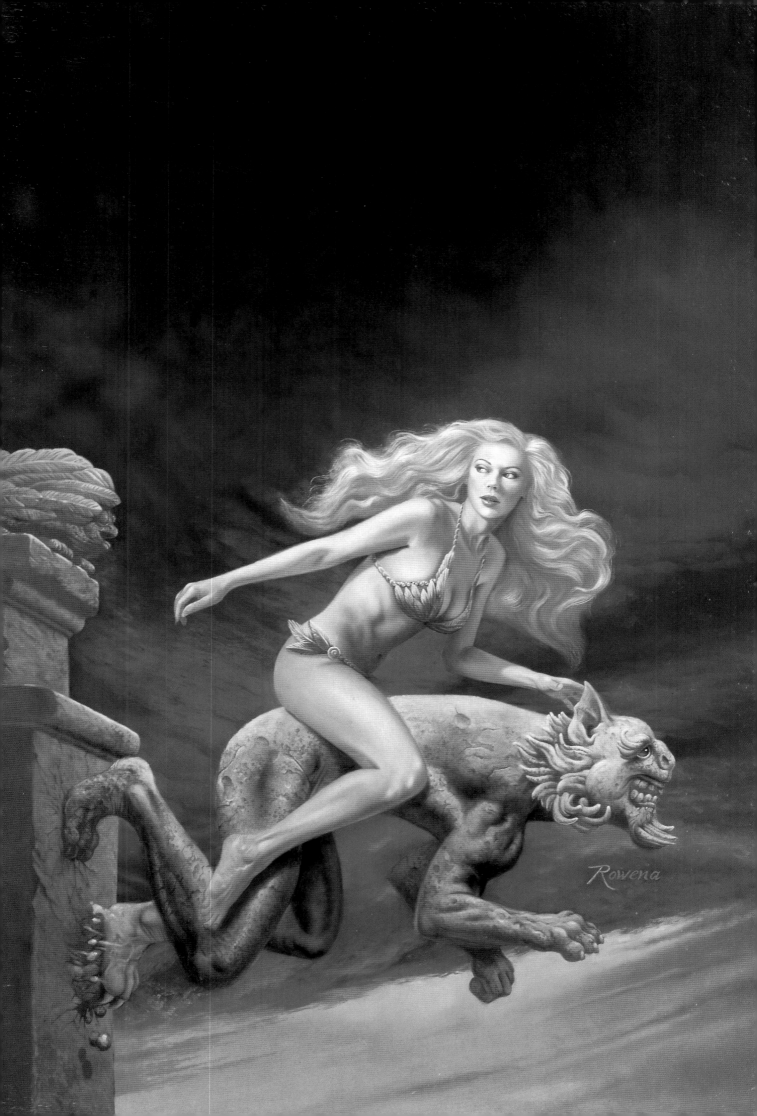

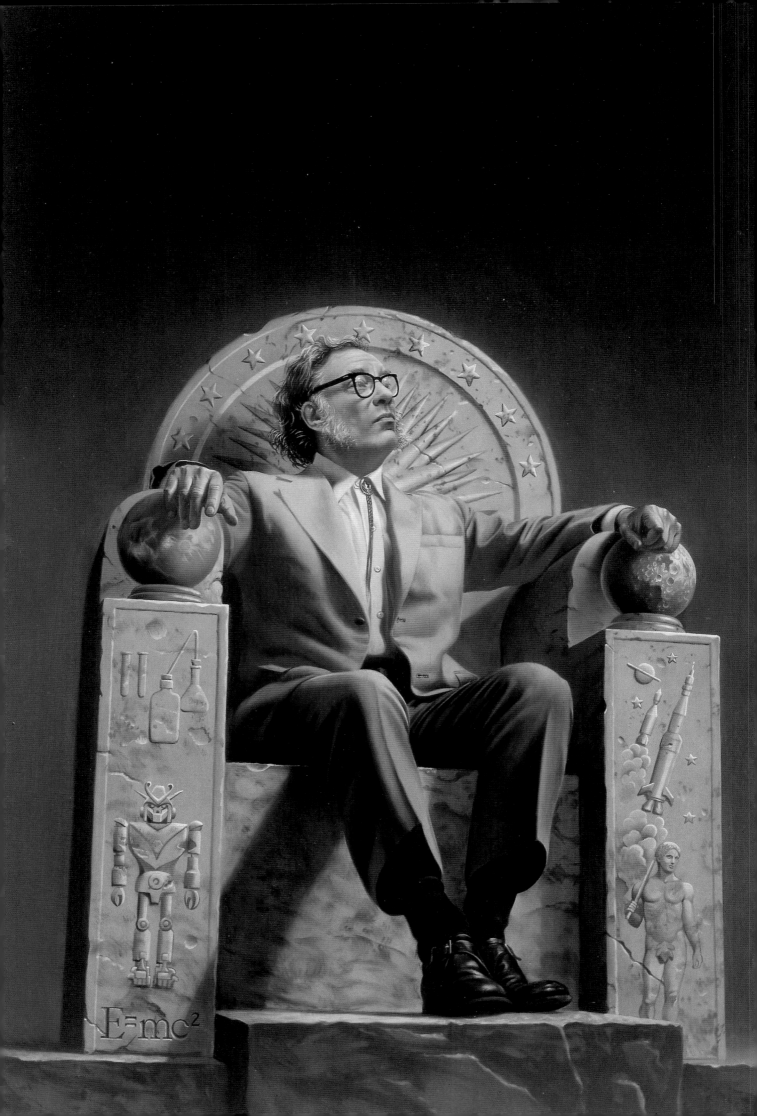

PORTRAIT COMMISSIONS

OPUS 100
ISAAC ASIMOV

*I*saac Asimov was not only a prolific writer but an amazingly good one. His books are packed with fascinating information. He certainly reached an exalted position in the world of science fiction literature, so I thought it highly appropriate to show him sitting on a throne.

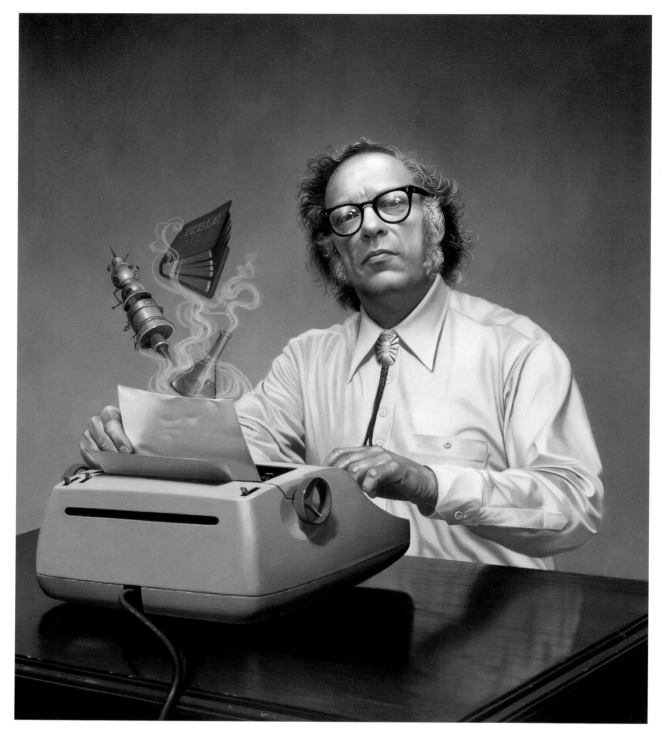

OPUS 200
ISAAC ASIMOV

'Just bring your little Brownie camera to the hotel where I am giving a lecture,' was Asimov's suggestion when I tried to set up an appointment for a portrait photograph. I ended up getting his likeness from xeroxes of newspaper cuttings.

Right:
PORTRAIT OF SUSAN FERER

Susan was a wonderful subject for a portrait with her dark, Mediterranean looks. An MIT graduate, she is now an aerospace engineer designing satellites and spacecraft for Hughes. It was a natural choice to place her in an outer-space background. The sphere floating above her hand is a visual expression of the polar coordinates. Next to it is a basic equation in her field with which you can determine the relative location of anything in the universe.

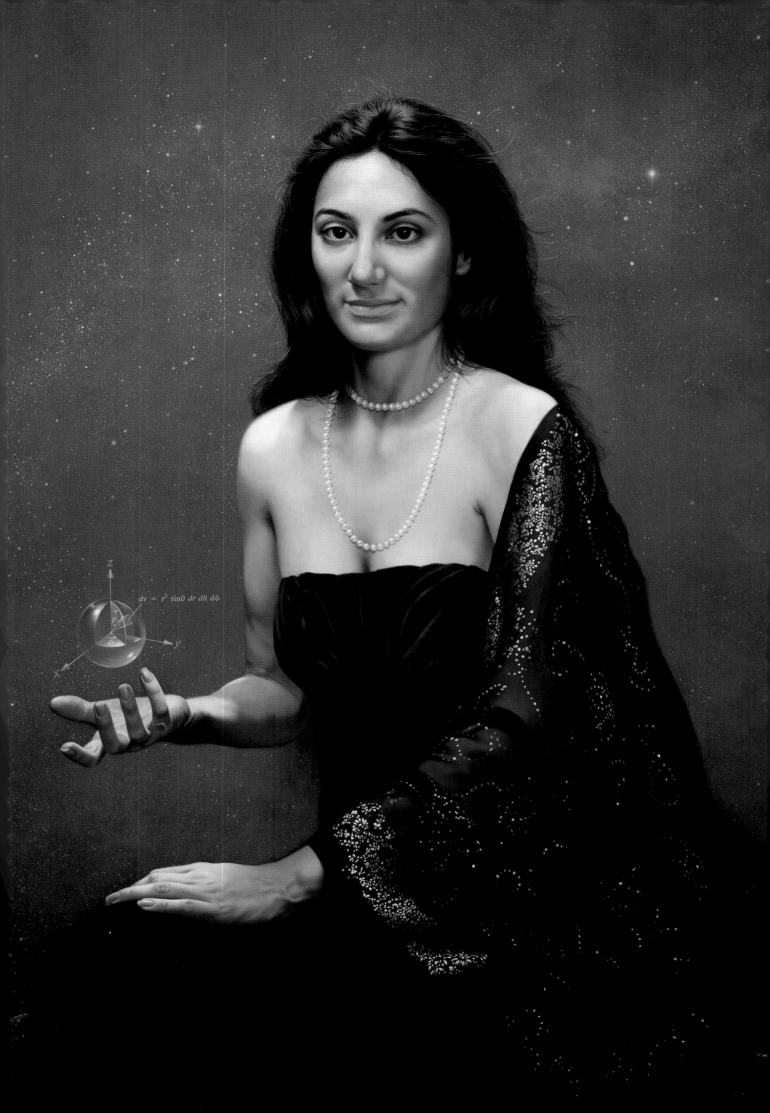

$$dv = r^2 \sin\theta \, dr \, d\theta \, d\phi$$

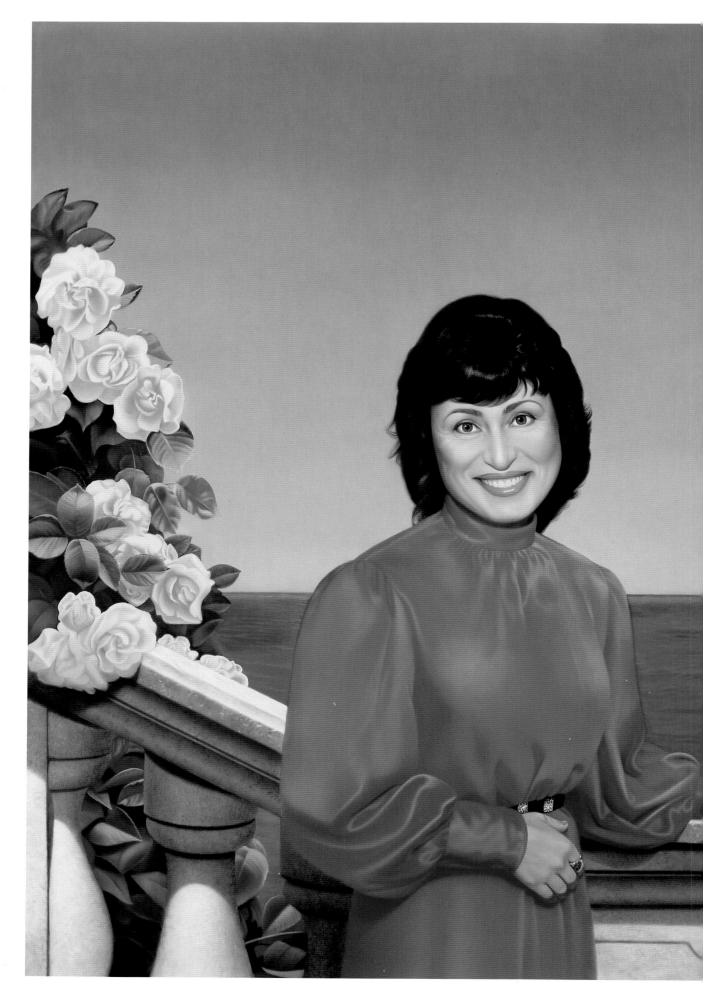

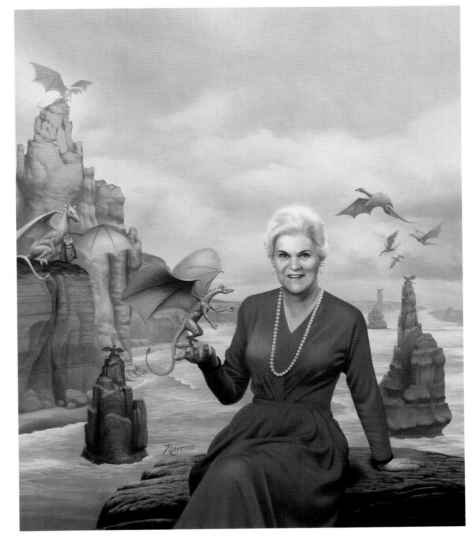

DRAGON HOLDER
TOD MCCAFFREY

This painting was for a biography of Anne McCaffrey, written by her son. It was very important to me – and, no doubt, to Anne and her son – that I paint a flattering likeness. I was given an excellent head shot of her but no reference at all for the rest of her so I selected a model based on faxes of head shots. Her body type turned out to be completely wrong, and painting a credible Anne McCaffrey figure became, I might say, a triumph of fantasy over unassailable fact.

Left:
PORTRAIT OF KIRA

It is one of the incomprehensible twists of fate that Kira Belilovsky, a woman who led such an admirable and inspiring life, should have been stricken down at so young an age by a fatal illness.

She immigrated to the United States from Russia in 1976 with her family and, within a few years, built up a major pediatric practice in Brooklyn, New York. She was revered and loved by a large community of friends and patients, many of whom literally owe their lives to her.

I tried to convey the personal charm and fine intelligence that radiated from her sparkling eyes.

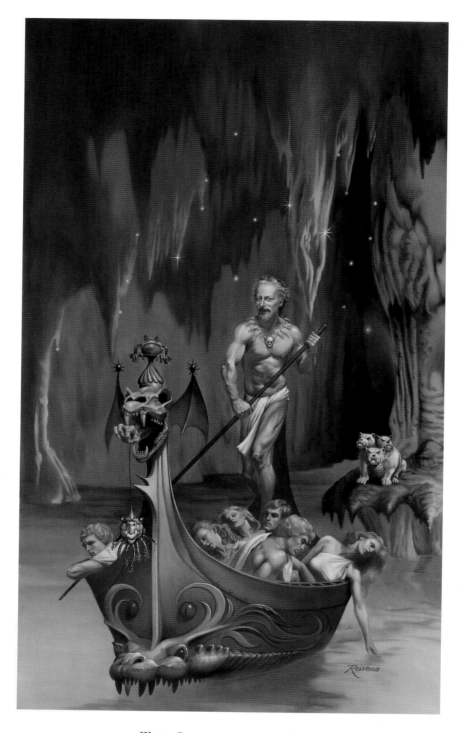

THE STARS ARE THE STYX
THEODORE STURGEON

One of my fondest memories of Theodore Sturgeon was when he was in the audience at a slide show I was giving at a science fiction convention. When it was time for questions, he raised his hand and said, 'I really like that painting you did for my last book cover, but I just have one observation. I'm a lot more muscular than that. Why didn't you make me bigger?' There was a burst of laughter from the audience because, in fact, he was a very slender man.

Left:
THE GOLDEN HELIX
THEODORE STURGEON

I did at least three portraits of Theodore Sturgeon, always with great pleasure. He was a playful man with a lively imagination and his face was so intriguing. He always radiated goodwill and is certainly missed in the science fiction and fantasy community.

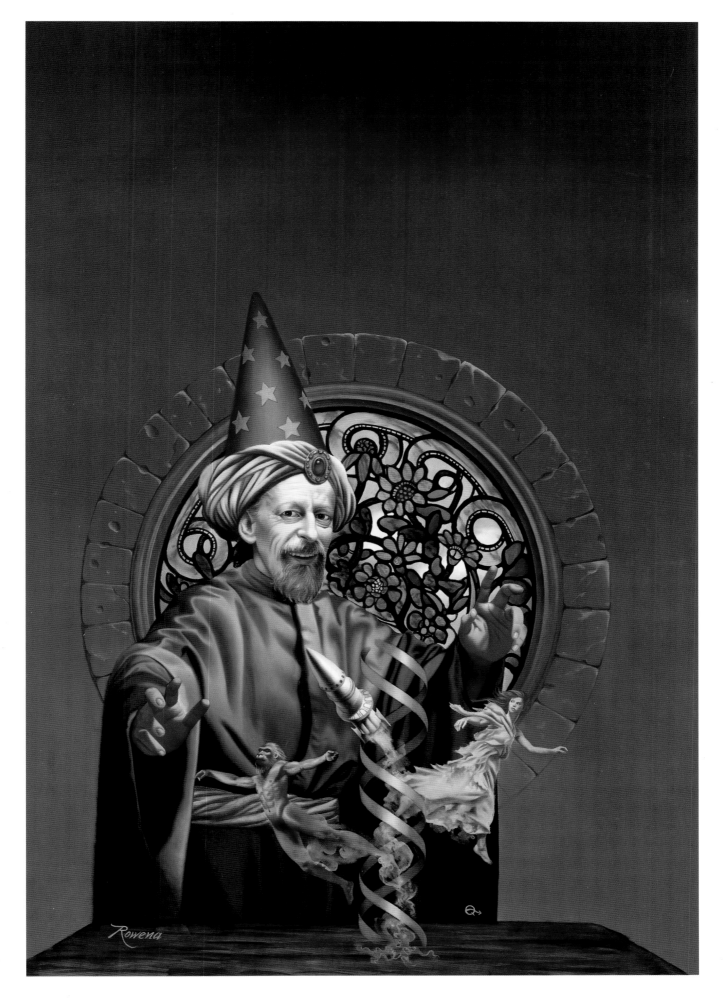

EPILOGUE
ROWENA: HOW I PAINT

IF A PICTURE is worth a thousand words, I want my images to be so clear that those words can remain unspoken. I try to make my paintings easily accessible to everyone. My technique is subordinate to that goal, and I have purposely avoided painting in a particular style.

Nevertheless, there seem to be unconscious influences that give any artist's work a signature look, as unique and automatic as handwriting. Whether I am doing a portrait, an illustration, or one of my own ideas, the result is always distinctly mine.

Apart from style, my ideas also seem to emerge from the subconscious. At first, it is purely by instinct that I am drawn to some irresistibly funny or beguiling notion. But looking back on the paintings I have done is like analysing the images of a Rorschach test. It can take several months after finishing a piece for me to become detached enough to understand the meaning of my own work.

Certainly, what I like to paint is just the natural outflow of what I like to see. It can be a rainbow, a waterfall, visions that I linger over, never wanting the moment to pass. It can also be the scrambled and perverse scenes in New York subway tunnels. All these sights make my imagination run wild.

I love to see the colours at the Great Barrier Reef. All day long the tropical water lays out a luminous palette ranging from misty green to splendid peacock blue, and in the evening the sunset casts a swathe of golden tones over the waves. Below the surface, I can scuba-dive in a paradise of brilliant-hued fish and revel amongst the stunning array of iridescent and opalescent life on the coral reef.

Being close to nature makes me daydream. When I have been hiking in the canyons of Southern Utah, it is like moving through the corridors of a labyrinth where I can suddenly find the entrance to a hidden city around the very next corner. As I look overhead, I like to imagine that the overhanging sandstone formations are turrets where crouching gargoyles are ready to spring to life.

It is mesmerizing to watch for the secondary imagery in a campfire or in the waves splashing onto a beach. All this makes me want to paint.

The three artists who have inspired me most are Bosch, Rubens and Ingres.

I wish I could go back in time and hide in the studio of Hieronymus Bosch. I want to know what kind of man created such a lexicon of bizarre images, with such an outrageous sense of humour. Even in the scenes of Hell, he painted the details with a light and whimsical touch. Poring over his paintings is like getting caught up in a gripping novel full of plots and intricate sub-plots. If one of his works were unearthed in a basement 300 years from now, I think it would fascinate the finder – no art critics would be needed to pontificate about its value.

Rubens, with a technique capable of handling anything that can be seen or imagined, is the artist I have learned most from. I spent years looking at his painting *Daniel in the Lion's Den* to get a grasp of skin tones while I was working on my own figures. I thank Rubens for his dramatic compositions full of people and animals writhing around in every position, and for his way of rendering silky, golden hair. His images stand out because of the gorgeous colours and the high contrast, ranging from pure white to deepest black.

Finally there is Ingres, whose paintings have the mystical quality of music. In his portrait of the Princess de Broglie, all lines and curves come together in perfect harmony. I have learned from studying his edges, like the ones so deftly softened around her face and shoulders. It appeals to me that he achieved mystery in his work without muddling the paint. His images are highly organized and clear to see.

For me, the magic of painting is to depict a three-dimensional image on a two-dimensional surface. I try to transform the paint into an illusion, like sea foam, a mermaid, or a granite deity.

My ideal painting would catch my eye from across a large room, yet I could get near enough to press my nose to the canvas and still be mystified by its details. When I look at a painting closely, I do not want my first thought to be, 'Ah, there's some paint.' That is why, in my work, I avoid brushstrokes, impastos or any other signs of labour that show how I did it. I am prejudiced because of my musical background. If I go to a concert and hear the flautist gasping for air between phrases, it spoils the illusion of an effortless melody.

Photograph by MAYA

Oils are my favourite medium because they are malleable and it is easy to round the form without tedious cross-hatching. But you can literally use a one-hair brush and get the crispest, most minute details. The rich colours glow like a stained-glass window when you apply layers of transparent glazing.

When I am working I try to get into a flow-state in which I am completely engrossed in the painting and unaware of time. I think of it as healthy exercise for the mind, the way going for a long run is good for the body. After a good day of painting, I feel wonderful. Perhaps it is similar to the state that Asian mystics try to achieve by meditation.

I like to play around and dream when I am getting the idea for a painting. Then, at the end, I want plenty of time to refine the details and to glaze on more layers of translucent colour. All that tinkering is what makes the difference between a tolerable piece and one that I am really happy with. Nothing beats the satisfaction if I have been successful.

For me, art is an escape. No matter where my body is, I can always take my mind on an adventure. To imagine wandering through a Frederick Church painting of the Andes, or to get caught up in the dazzling sounds of a Tchaikovsky symphony,

gives me a wonderful break from the daily routine. As much as I can, I like to create something that might be a diversion for others.

My experience is that beautiful moments unite people. During a well-sung aria in an opera, I enjoy being surrounded by 2,000 people, all spellbound at once by the music. Or when I have been part of a group standing under the frescoes in the Sistine Chapel, I felt that we shared a sense of enchantment and that we were all thinking in unison.

In the end, I think art is a great consolation. I recently lost my beloved cat, Buttercup, who died of cancer. He was my constant companion for 15 years, day and night, and during nearly every painting in this book. I have felt a very primitive level of grief for him and the *only* relief has come from writing music and painting.

The great fifteenth-century painter Jan van Eyck inscribed on his painting of *The Man with the Red Turban*, 'Als Ich Kan', meaning 'As I Can' (not 'As I Would'). In no way could I ever compare myself to van Eyck, except in intention. I work as well as I can, not as well as I wish I could. If my paintings ever give anyone a moment of distraction or pleasure, I am content.

Rowena A. Morrill
New Jersey, December 1999

ROWENA MORRILL

EDUCATION:

University of Puget Sound, Tacoma, Washington
University of Delaware, Newark, Delaware, BA in Art
Pennsylvania Academy, Philadelphia, Pennsylvania
Art Students' League, New York, N.Y.

BOOKS:

Tomorrow and Beyond (Anthology)
 Workman Publishing, 1978
The Fantastic Art of Rowena
 Pocket Books, 1983
Imagine
 Zoom Publishing, 1985
Imagination
 Volksverlag, 1985
Meisterwerke Der Fantasy – Kunst (Anthology)
 Taco Verlag, 1986
Masterpieces of Fantasy Art (Anthology)
 Benedikt Taschen Verlag, 1991
Infinite Worlds (Anthology)
 Penguin-Putnam, 1997
Martin Bear and Friends (Illustrated)
 Hastings House, 1997

CALENDARS:

Tolkien Calendar (Anthology)
 Ballantine Publishing, 1981
Rowena Calendar
 Landmark Publishing, 1986
Rowena Calendar
 Landmark Publishing, 1987
Rowena Calendar
 Landmark Publishing, 1988
Rowena Calendar
 Landmark Publishing, 1989
Rowena Calendar
 Landmark Publishing, 1990
Heavy Metal Calendar (Anthology)
 Heavy Metal Publishing, 1993
Science Fiction Book Club Calendar (Anthology)
 Science Fiction Book Club, 1996

PORTFOLIOS:

The Art of Rowena
 Schanes & Schanes, 1983
Fantasy Poster Book (Anthology)
 Taco Verlag, 1987

TRADING CARDS:

Heavy Metal Trading Cards (Collections)
 Heavy Metal Publishing, 1991
National Lampoon Trading Cards (Collections)
 National Lampoon, 1993
Rowena Fantasy Art
 Friedlander Publishing Group, 1994

Colossal Cards (Collections)
 Friedlander Publishing Group, 1994
Rowena Chromium Cards
 Friedlander Publishing Group, 1996

MAGAZINES:

Omni (work featured)
 Omni Publications, December 1982
The Best of *Omni* #5 (work featured)
 Omni Publications, Vol. 5, 1983
The Best of *Omni* #6 (work featured)
 Omni Publications, Vol. 6, 1983
Zoom Magazine (article about Rowena)
 Zoom Publishing, Spring 1985
Omni (article about Rowena)
 Omni Publications, January 1988
Italian *Playboy* (article about Rowena)
 Playboy Publishing, February 1989
Omni (work featured)
 Omni Publications, October 1989
Omni (work featured)
 Omni Publications, February 1990
KIJK Magazine (work included)
 KIJK Publishing, September 1992
Realms of Fantasy (article about Rowena)
 Sovereign Media, December 1999

EXHIBITIONS:

University of Delaware, Newark, Delaware
International House, University of Pennsylvania,
 Philadelphia, Pennsylvania
Harvard College, Cambridge, Massachusetts
Cheltenham Arts Center, Cheltenham, Pennsylvania
Wallnuts Gallery, Philadelphia, Pennsylvania
Ursinus College, Pennsylvania
Earthlight Gallery, Boston, Massachusetts
Hansen Art Gallery, New York, N.Y.
Pendragon Gallery, Washington, D.C.
Kent State University, Ohio
The Gallery of Illustration and Fine Art, Philadelphia,
 Pennsylvania
The New Britain Museum, New Britain, Connecticut
Delaware Art Museum, Wilmington, Delaware

Numerous science fiction and fantasy conventions, USA

TEACHING EXPERIENCE:

Parsons School of Design
 Guest Lectures
Joe Kubert School of Cartoon and Graphic Art
 Painting Techniques
University of Delaware
 Figure Drawing, Illustration

INDEX OF WORKS

All paintings are in oil, and most are done on gessoed illustration board, except for the personal paintings and the portrait commissions, which are done on masonite.

Overleaf:
THE LAST WAVE

To leap into the foam-crested curl of a wave and somersault down its silky back brings me an unparalleled thrill of delight.

Of course, there is never a *last* wave. Nonetheless, I always sense that I am clinging to the final one as the time draws near to leave a beautiful beach at the end of the summer. This piece expresses the nostalgia I feel throughout the tenacious, grey winter, for that one last wave.

Using an ABA construction, I tried to convey a feeling of long, rhythmic undulations in the first and third sections. In the middle part I wanted to imitate the tones of delicate ripples overlapping each other as they roll along the sand.

The Last Wave

For Dandelion

Rowe

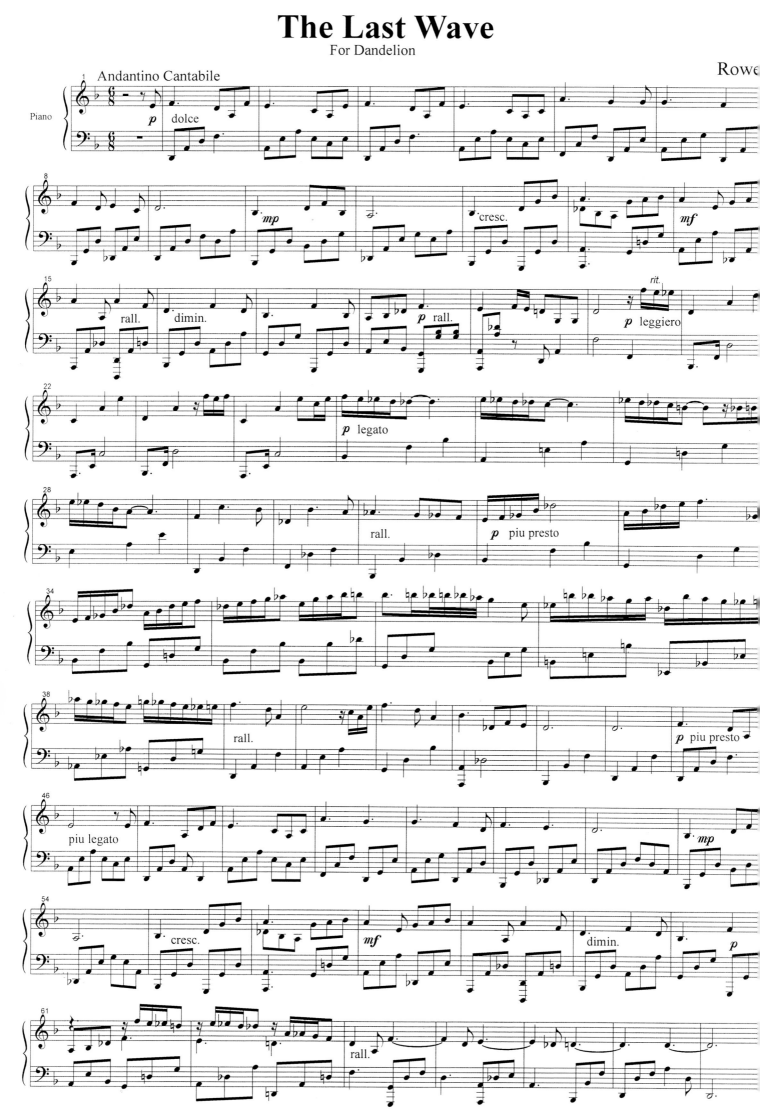